IPSWICH IN 50 BUILDINGS

CALEB HOWGEGO

AMBERLEY

Acknowledgements

My sincere thanks to God, my family and friends for their encouragement and support throughout my work on this book. My uncle, Richard Davies, has kindly provided a great amount of help and advice with the photography featured in this book, which I would like to thank him very much for here. Thanks also to the many people who have kindly proofread parts of the book. I would particularly like to thank Alison Byam in this regard, who spent many hours reading through text and offering improvements.

The photograph of the Victorian Natural History Gallery in Ipswich Museum is reproduced with kind permission of Colchester and Ipswich Museums Service from the Ipswich Borough collections. The photograph of the interior of Ipswich Institute is reproduced with kind permission of Ipswich Institute. The photograph of the Regent Theatre auditorium is reproduced with kind permission of Ipswich Borough Council.

For my nephew Ewan Howgego

First published 2019

Amberley Publishing, The Hill, Stroud
Gloucestershire GL5 4EP

www.amberley-books.com

British Library Cataloguing in Publication Data.
A catalogue record for this book is available from the British Library.

ISBN 978 1 4456 7999 0 (print)
ISBN 978 1 4456 8000 2 (ebook)

Typesetting by Aura Technology and Software Services, India.
Printed in Great Britain.

Contents

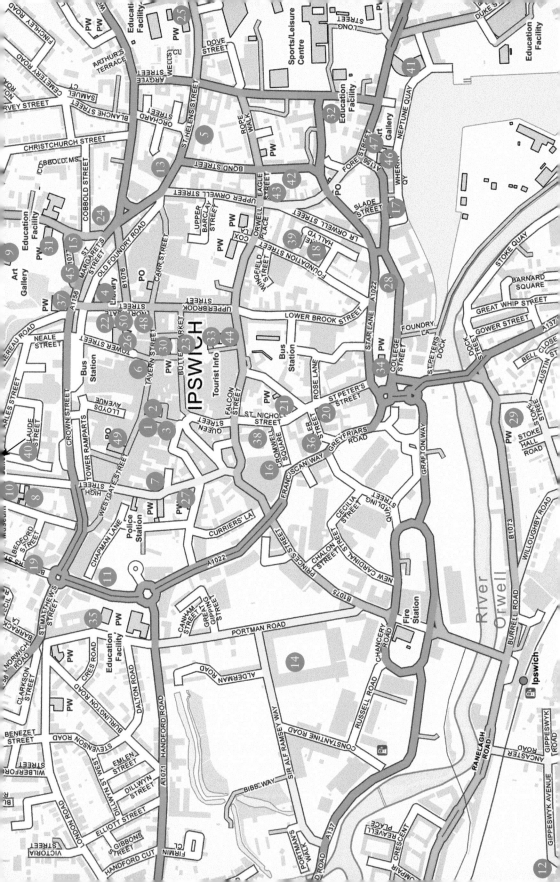

Key

1. Town Hall
2. Old Post Office
3. Corn Exchange
4. Ipswich County Library
5. Ipswich County Hall
6. Ipswich Institute
7. Arlingtons
8. Ipswich Museum
9. Christchurch Mansion
10. Ipswich Art Gallery
11. New Wolsey Theatre
12. Gippeswyk Hall
13. Regent Theatre
14. Portman Road Stadium
15. Freemasons Hall
16. Willis Building
17. Old Custom House
18. Tooley's Court
19. Ipswich and East Suffolk Hospital
20. Sailors' Rest
21. Curson Lodge
22. Pykenham's Gatehouse
23. Ancient House
24. Manor House
25. St Helen's Church
26. St Mary-le-Tower Church
27. St Mary at the Elms Church
28. St Mary at the Quay Church
29. St Mary at Stoke Church
30. St Lawrence Church
31. St Margaret's Church
32. St Clement Church
33. St Stephen's Church
34. St Peter's Church
35. St Matthew's Church
36. St Nicholas Church
37. Bethesda Baptist Church
38. Unitarian Meeting House
39. Blackfriars Ruins
40. Ipswich School
41. University of Suffolk Waterfront Building
42. Ipswich Ragged School
43. The Spread Eagle
44. The Sun Inn
45. Old Packhorse Inn
46. Isaacs on the Quay
47. Old Neptune Inn
48. Great White Horse Hotel
49. Crown and Anchor Hotel
50. Royal Oak

Introduction

When I first sat down to work on this book, I thought it might be difficult to find fifty buildings in a town the size of Ipswich that would be noteworthy enough to write about, but I soon found that quite the reverse was the case. In fact, the real challenge was not so much finding buildings with interesting histories, but deciding which ones I would have to leave out.

Ipswich is a lot older than it first appears, which is mainly due to the lack of historic architecture our ancestors have left us. For a town that claims to be the oldest continually inhabited in England, precious few truly ancient buildings are obvious to the casual observer. This is mainly thanks to the cycles of decline and prosperity that Ipswich has seen over the centuries. In times of prosperity those who could afford to made their mark on the town – often at the expense of older constructions. Consequently, small fragments from each century remain scattered around the town in an intriguing hotchpotch of old and new.

Take three of the buildings in the area surrounding Cromwell Square, a small, nondescript car park along St Nicholas Street, by way of an example. Firstly, we have St Nicholas Church, itself a jumble of fine medieval and Victorian flint and stone architecture. Then there's the Unitarian Meeting House, a celebrated timber-framed chapel, which opened in 1700 and is the oldest building of its type in East Anglia. These first two structures are reflected in the large, dark, glass exterior of the Willis Building, a modern masterpiece of building design, which became the youngest building in the country to be awarded Grade I listed status in 1991 and remains one of the youngest so rated to this day. Three architectural gems from different ages all within a stone's throw of each other. When you start looking closer, you find pockets of remarkable architecture like this the whole town over.

It is a shame that the town has not done a better job of holding on to some of its finest architectural treasures, but it could equally be said that a long-held spirit of embracing change is as much a part of the heritage of Ipswich as any building may be said to be. This may also be part of the reason the town has always managed to return to prosperity after periods of decline.

Ipswich's reaction to one period of decline, caused by the decreasing navigability of the River Orwell in the eighteenth century, helps us understand why the town appears as it does today. Prior to this, Ipswich was a prosperous merchant town as a centre for the trading of grain, cloth and wool. The twists and turns of the River Orwell, along with the silting of the docks at Ipswich, caused increasing problems for merchants, leading to a slump in the town's economy. At the beginning of the

nineteenth century, the town took dynamic action to reshape portions of the river and create the largest wet dock in the country at the time. This played a huge part in powering the renewed industry that followed in Victorian Ipswich and paved the way for redeveloping huge swathes of the town in order to keep pace with the needs of the fast-growing population. This helps explain why so much of the important architecture left to us today was either built or altered during the Victorian era.

The downside of sweeping changes like this is that some of Ipswich's most fascinating architecture has been masked or demolished, but get below the surface – the challenge I set myself in this book – and you'll see that Ipswich is crammed with architectural treasures from across many centuries.

I hope you enjoy exploring Ipswich's history through the lens of fifty of its buildings and that it encourages you to take a closer look for yourself.

The 50 Buildings

1. Town Hall

The history of important buildings on this site goes back a long way. The current Town Hall stands roughly where St Mildred's Chapel was once located, which was built around AD 700. The chapel slowly morphed into a civic building during the 1400s, eventually becoming known as a Guildhall (a place for guilds to meet) and a Moot Hall (a place for the council to meet). By the nineteenth century the building was showing its age and attempts were made to make it better suited for its role as Town Hall, including updating the frontage in 1818. Until some building work that took place in 1841, the cellars of the building still contained part of the ancient St Mildred's Chapel. By the 1840s, after further modifications, the Town Hall contained a council chamber, a police station and a museum room run by the Ipswich Literary Institution. The current Town Hall was built in 1866–67 in the Venetian style to replace the former building. Four statues stand upon the front façade of the current Town Hall and there appear to be conflicting opinions from sources as to what they actually symbolise, but to the best of my figuring they represent commerce, learning, justice and agriculture. The clock tower bell that still rings the hours to this day is as old as the building itself – it was cast in 1867. The current Town Hall housed much of civic life for a century, but in the 1960s, due to lack of space, various borough council departments began to move out and as they did so it became necessary to find a new purpose for the building. So it was that the 1970s saw the building take on a new role as a place for holding events, taking bookings from all manner of organisations and societies for their meetings, dinners, concerts and exhibitions. This proved so successful that the council decided to convert the neighbouring Corn Exchange for the same use, thereby increasing the joint complex's flexibility for staging events. The Town Hall still also plays a municipal role in Ipswich by housing the mayor's office.

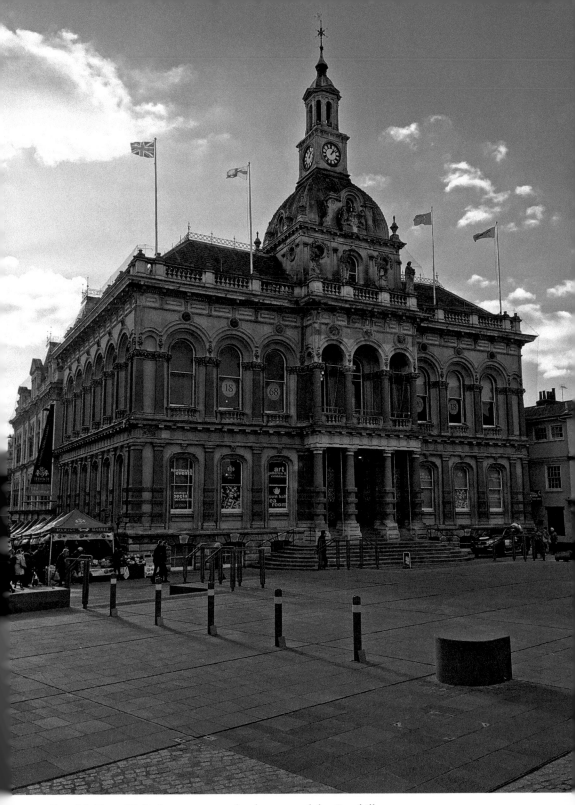

Ipswich Town Hall after a recent redevelopment of the Cornhill.

2. Old Post Office

The Old Post Office stands on what was once the location of the town's shambles, where butchers and fishmongers traded. This grand new post office was opened on 27 July 1881, as part of a wide-ranging attempt to keep up with the demand placed upon a growing Victorian Ipswich. On the same day the new museum on High Street and a new lock gate at the docks were also opened. The four seated female figures on top of the front of the building represent industry, electricity, steam and commerce – all truly Victorian motifs. Although the building has long since moved on from taking part in this Victorian vision of industry, the four figures that represent it have remained intact. The most recent use of the building was as a home to a branch of Lloyds TSB, but it has remained empty for some years now. In 2018, Ipswich Borough Council led a project to redevelop the Cornhill, where the now Grade II listed Old Post Office stands as one of the most prominent buildings. It is to be hoped that a new use can be found for this building as plans to regenerate the town centre progress.

The Old Post Office.

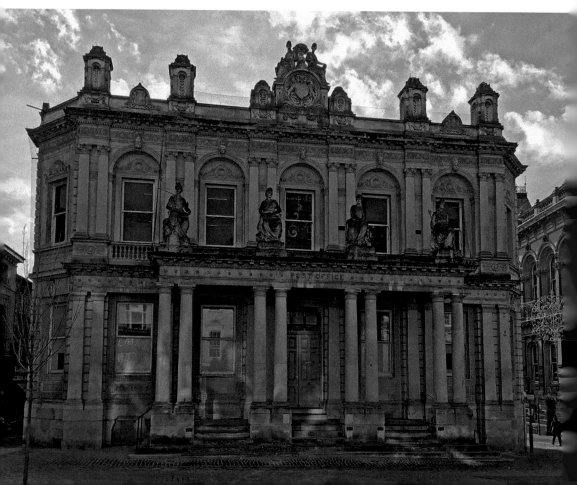

3. Corn Exchange

The foundation stone of the modern Corn Exchange was laid in 1880 and the building was opened in 1882. Inside the building, farmers used to set up stands in the hall to display samples of their crop, which buyers' representatives would examine, testing the quality of the grain. The Corn Exchange remained a place for the testing, buying and selling of corn for many years. However, eventually the way that farmers sold their produce changed and it became unnecessary for them to meet at the Corn Exchange in town and so on 29 June 1972 the final corn market took place. The Corn Exchange began its new role as an entertainment venue in 1975, combining with the neighbouring Town Hall as a joint complex for hosting events and performances. The huge space inside was divided by making two floors: the Robert Cross Hall (currently occupied by a branch of Waitrose) and the Grand Hall above, used as a venue for music and comedy performances. The building is so large that it also manages to house the Ipswich Film Theatre – an independent cinema with two screens, specialising in independent and world cinema – in its basement.

The Corn Exchange.

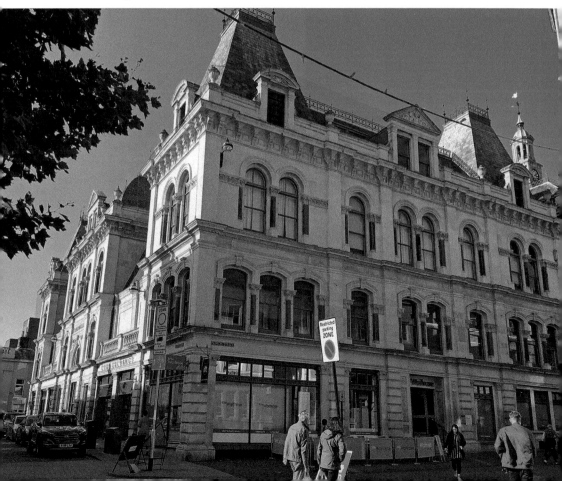

4. Ipswich County Library

Before the library moved to its current purpose-built building on Northgate Street, it was located inside Ipswich Museum. The history of a town library in Ipswich originates with William Smart leaving a collection of books and manuscripts to the town upon his death in 1599, which for some time were used by the town lecturer, Samuel Ward, in the writing of sermons that he gave to the townspeople in the seventeenth century. The current Ipswich County Library was officially opened in September 1924 by Sir Charles Sherrington (then the president of the Royal Society), who had grown up in Ipswich and attended Ipswich School. The most historically interesting room inside is the Northgate Room, with its 100-foot-long vaulted ceiling and old oak bookshelves, tables and glass windows that depict famous historical figures with links to Suffolk, including Geoffrey Chaucer, Francis Bacon and Thomas Wolsey. Today, this room is still used not only as a reference library, but also as a wedding ceremony venue. Extensive work to refurbish and extend the library was carried out in the 1990s, before which time a pulley-operated lift was still being used to move books from floor to floor.

Opposite: Ipswich County Library.

Below: The Northgate Room in Ipswich County Library.

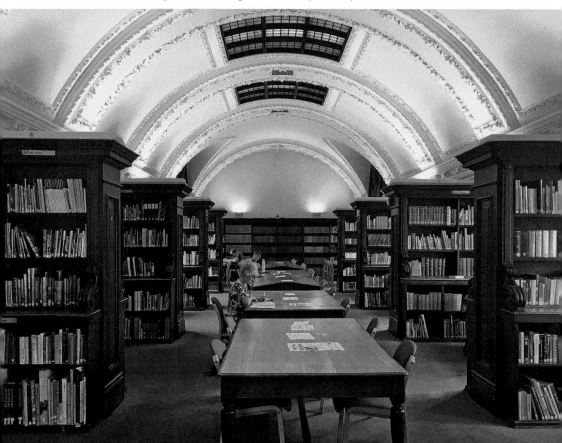

5. Ipswich County Hall

A jail that housed debtors and felons was established along St Helen's Street in the 1780s. In 1821 the treadmill was introduced to the jail as a form of punishment, which was a new invention of the engineer and inventor William Cubitt, who worked for the engineering company Ransomes in Ipswich for some time. The current building was designed by W. McIntosh Brookes and was built in 1836–37, with extensions made in 1906 in a matching style. The frontage along St Helen's Street, with its towers and battlements, is around 250 feet long and built with gault brick (a type of cream- or yellow-coloured clay brick popular in nineteenth-century architecture). For many years this was the place where justice was served in Ipswich. A set of gallows was erected behind its walls and as recently as the 1920s men were hanged at the site for committing murder. However, the most influential case was heard when Wallis Simpson, who was then in a relationship with Edward VIII, obtained her divorce in this building. In the autumn of 1936

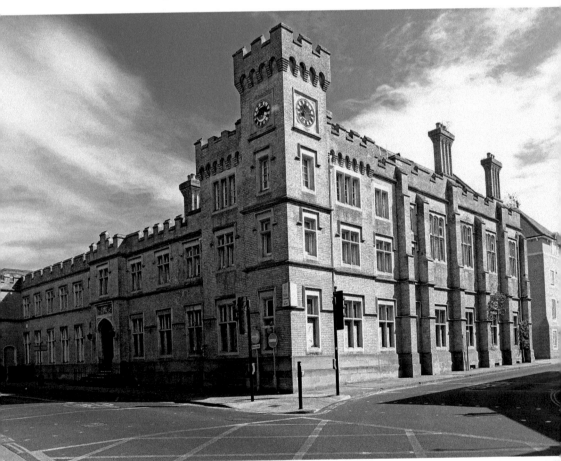

Above and opposite: Ipswich County Hall.

Wallis Simpson spent six weeks living in Felixstowe in order to gain residential qualifications to have her divorce hearing held in Ipswich, where it was hoped to attract only minimal publicity. Unfortunately for Mrs Simpson, the Associated Press of America was informed of the pending case and the world's press arrived in Ipswich for the hearing, which was to take place on 27 October. The hearing itself lasted only twenty-five minutes. After the judge had agreed to permit her divorce, Wallis Simpson rushed out of the court and was driven at high speed to London. The hearing in Ipswich led to a crisis that was only resolved in December 1936 when Edward VIII announced his abdication so that he could marry Wallis Simpson. The building has been unoccupied since around 2004 when Suffolk County Council sold it and moved to Endeavour House in Russell Road. The site has suffered such sustained vandalism that it is now in poor repair inside. Several plans have been proposed for this building in the years since its closure, but its future remains uncertain.

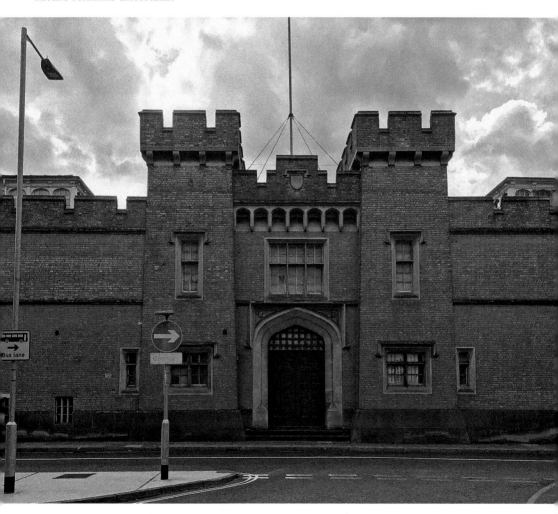

6. Ipswich Institute

Ipswich Institute's roots are found in the Mechanics' Institutions movement that began in the early 1800s. Dr George Birckbeck wanted to remove obstacles in the way of intelligent tradespeople gaining knowledge in scientific matters and his work became formalised in Mechanics' Institutions, where adults could gain academic education and make use of libraries and reading rooms. In 1824 a meeting was held to establish such a society in Ipswich, aiming to set up a library and reading room, museum and lectures for its members. Of those set up in the original burst of enthusiasm for Mechanics' Institutions in the 1820s, the institution in Ipswich is one of very few to still be open and providing educational classes. The original location for the Ipswich Mechanics' Institution was a schoolroom in St Matthew's Church Lane, where instruction in geometry and drawing were offered and a library set up. Soon it was considered desirable to find more central premises, and a move to the Buttermarket was

The entrance to Ipswich Institute.

made, where the institution hired rooms for eight years. In 1831 the institution began buying a daily newspaper (second-hand, the day after publishing) so that members who wished to could take a ten-minute turn reading it, as measured by a sandglass – an example of how much communication has changed over the past two centuries! The society also started collecting objects for a museum, beginning with the presentation of 'a cat which was found starved to death in the roof of a building after being missed five years'. Other exhibits included more natural history specimens, such as the skeleton of a whale. In the end some objects were removed because of their decomposing states, and eventually all the remaining specimens were sold for a total of £15. In 1834 the institute moved to its current location in Tavern Street, which over time expanded to also occupy premises on Tower Street, including the former home of Admiral Benjamin Page (1765–1845), who retired to Ipswich after a distinguished career in the navy. Ipswich Institute continues to provide a library and reading room, as well as learning programmes for subjects such as arts, languages and history.

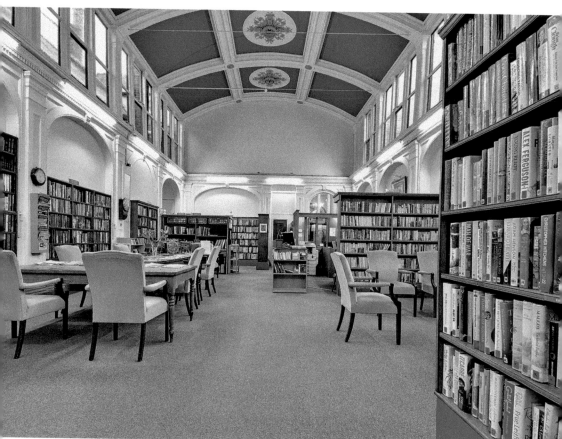

Ipswich Institute's reading room. (Courtesy of Ipswich Institute)

7. Arlingtons

This building, constructed in 1847, was the original home of Ipswich Museum. However, there were even earlier attempts to establish a museum in the town. The Ipswich Mechanics' Institute was founded in 1824 and was successful in setting up a museum, as was the Ipswich Literary Institution, which had a museum room upstairs in the old Town Hall. Both these museums became neglected and eventually a group of philanthropists came together to establish a newly built museum, which opened on 15 December 1847. The original remit was 'to promote the study, and extend the knowledge, of natural history in all its branches, and of the arts and science generally, by the establishing of a Museum'. Revd William Kirby was the first museum president, which must have been a long-awaited satisfaction to him as he had written to the Linnaean Society of London suggesting the foundation of a local natural history institution as

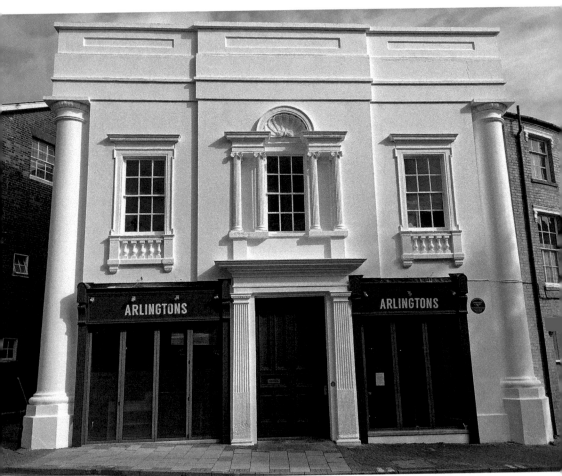

Arlingtons now inhabits the building that was originally Ipswich Museum.

far back as 1791. Kirby was succeeded as president by Revd Professor John Henslow, who among many other distinctions was Charles Darwin's tutor at Cambridge University and was responsible for sending him on his famous voyage upon the HMS *Beagle*. Darwin once wrote of Henslow: 'I fully believe a better man never walked this earth.' Ipswich Museum proved popular and was even visited by Prince Albert in 1851. According to Queen Victoria he talked of scarcely anything else for several days after his visit. The museum ran into financial difficulties in 1852 and it was no longer possible to run it on private income. The following year local ratepayers voted strongly in favour of saving the museum by taking it into public ownership, making it one of the oldest local-authority-run museums in England. So successful was the museum that it had soon outgrown its building on Museum Street and moved to a newly designed building on High Street. The building on Museum Street went on to be used as a dance hall for many years, but today it houses Arlingtons, a restaurant and café bar. The Museum Street building is now Grade II listed and the exterior remains little changed from its museum days.

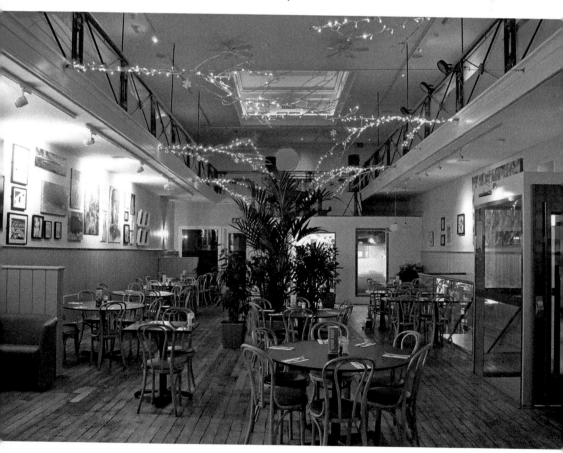

Inside Arlingtons.

8. Ipswich Museum

Ipswich Museum was once, appropriately enough, based on Museum Street, but eventually, as the collections began to outgrow these premises, a new building was planned on High Street (so named for its elevation rather than for being a central shopping location). The new building, which opened on 27 July 1881, also came to house a library and schools of science and art, as well as the enlarged museum. Over the years the library and schools moved out to new locations and museum collections have continued to expand to colonise the spaces they left behind. The exterior of the museum is of red brick and decorated in places with ornate terracotta panels that contain images of fossils, floral designs and technical equipment associated with the study of science and art. There have been many notable individuals with connections to Ipswich Museums over the years. Basil Brown is one such character. He worked as a freelance archaeologist and a museum attendant for Ipswich Museum

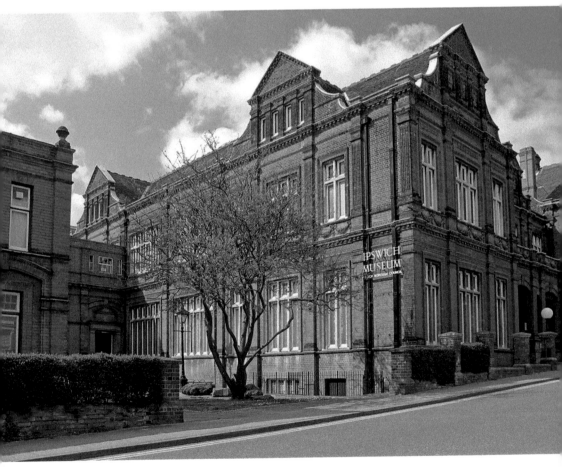

Ipswich Museum, High Street.

and is best known for discovering the Sutton Hoo ship burial in 1939. Nina Frances Layard is another. She was a prehistorian and archaeologist who pioneered a role for women in these areas, becoming one of the first women to be admitted as a fellow of the Society of Antiquaries of London. Although not formally employed by the museum, Layard took a leading role on many important excavations that contributed many of the museum's most important archaeological artefacts. Currently, some parts of the complex of museum buildings are used by the New Wolsey Theatre as a rehearsal space, as well as the base for the Pacitti Company, a performing arts organisation. The museum continues to offer free entry to visitors and includes galleries featuring impressive local history, geology and world cultures collections. However, the museum's crowning centrepiece is its Victorian Natural History Gallery, where some of the museum's most cherished exhibits are on display, including Rosie the rhino, who was at the centre of a news story in 2011 when her horn was stolen (which has since been replaced with a replica), and an adult giraffe that was delivered from London to Ipswich by rail in 1909.

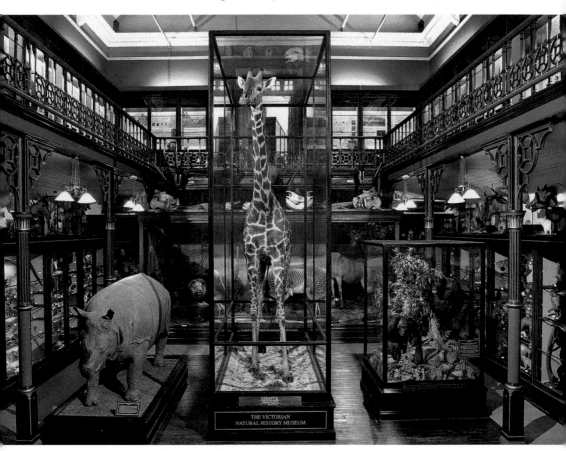

The Victorian Natural History Gallery in Ipswich Museum. (Courtesy of Ipswich Museums)

9. Christchurch Mansion

The Augustinian Priory of the Holy Trinity (also referred to as Christchurch) was set up in the twelfth century in what is now known as Christchurch Park. The priory and its surrounding estate was suppressed in 1536, and the land appears to have passed hands several times before eventually being sold in 1545 to Paul Withypoll, whose son Edmund began to build a house in 1548 on the site where the priory probably once stood. In the 1640s the mansion and estate passed into the ownership of the Devereux family, who made many changes to update the interior and exterior of the building to meet contemporary fashions. In 1735 the mansion came into the possession of another wealthy merchant, Claude Fonnereau, who was the son of a Huguenot refugee from Normandy. The house remained in the care of his family for several generations, during which time further additions were made to the building. In 1892, Christchurch

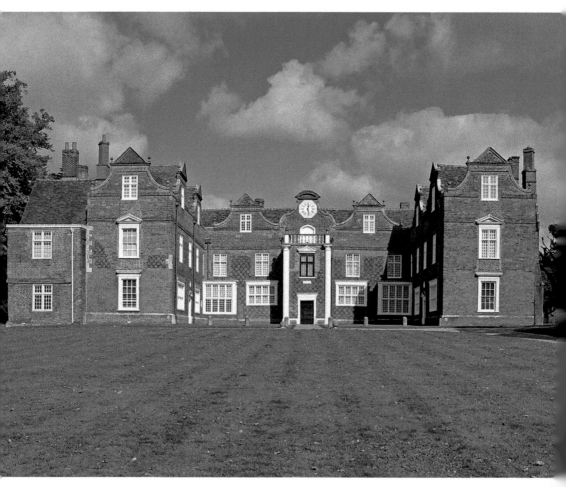

Christchurch Mansion.

Mansion was put up for sale. It was offered to the Ipswich Corporation, but the local ratepayers initially voted against its purchase. It was left to Felix Thornley Cobbold, of the famous brewing family, to save the future of this building. He did so by purchasing Christchurch Mansion and its grounds as part of a property syndicate and then offering to gift the mansion to the town on the condition that it was preserved and that the corporation purchased the remainder of Christchurch Park. By 1896 both the park and the mansion were open to the public for free. Part of a Tudor merchant's house at Major's Corner was saved from demolition in 1924 and reconstructed on the back of the mansion. The addition of the purpose-built Wolsey Art Gallery was made in the 1930s. Christchurch Mansion has now been open as a free museum for over 120 years, and is one of the most celebrated and iconic buildings in Ipswich. The museum, now housed within the mansion, has a particularly rich collection of early oak furniture and artworks by artists such as John Constable and Thomas Gainsborough on display.

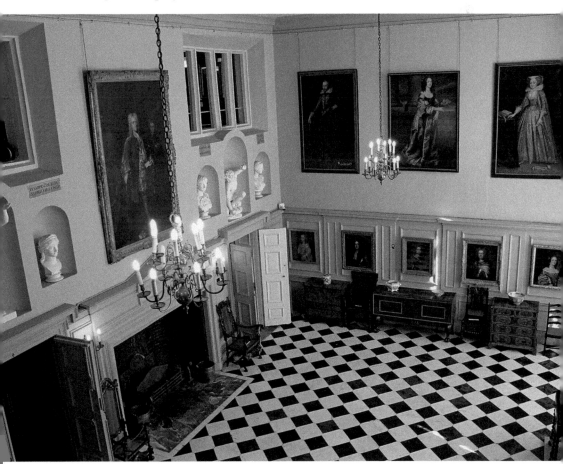

The Great Hall, Christchurch Mansion.

1c. Ipswich Art Gallery

Before becoming an art gallery, this building was once home to the Ipswich School of Art. The school was originally based in the Assembly Rooms in Northgate Street from 1859. In the mid-1800s the idea took hold that the study of science would be complimented by training in the visual arts and would produce a higher quality of designers in industry. So it was that, in Ipswich, the decision was made to link the schools of Science and Art, and they were both duly incorporated within the newly built museum buildings on High Street shortly after they opened in 1881. If you look closely at the terracotta panels on the outside of Ipswich Museum today it is still possible to see depictions of the heads of Newton (to represent science) and Hogarth (to represent art) set into the brickwork. Soon more teaching space was needed and a three-module single-storey extension to the north of the museum was built – one used by the school of art, one as a chemical laboratory, and the other as a chemical lecture

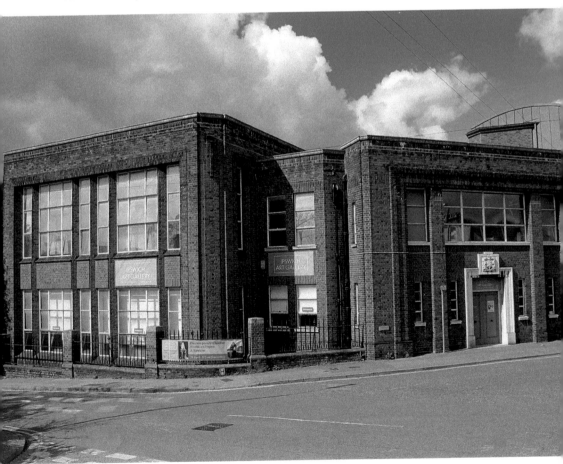

Ipswich Art Gallery.

room. In 1934 work began on another new extension for the growing art school, which incorporated an octagonal glass-roofed central atrium as an exhibition space. Talented and well-known teaching staff from the heyday of the Ipswich School of Art included Colin Moss, Bernard Reynolds and Leonard Squirrell, and students such as the children's writer and illustrator Helen Oxenbury, as well as Brian Eno and Maggi Hambling. The building continued to be used as a school of art until its closure in 1997 when all the teaching moved to the main Suffolk College campus. In 2010 the building opened as an art gallery run by Ipswich Museums on lease from Suffolk New College and was then, after fundraising, bought in 2012 and officially added to the museum service. Today, the former art school is now open to the public as the Ipswich Art Gallery, with a revolving programme of in-house and touring exhibitions. Many of the teachers and students from the school are now represented within the fine art collections of Ipswich Museums.

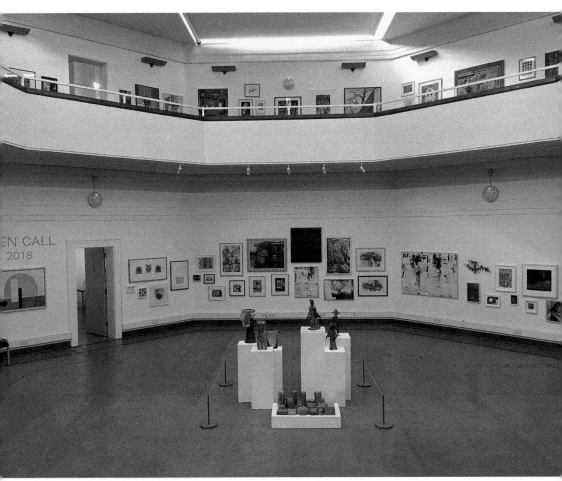

The atrium in Ipswich Art Gallery.

11. New Wolsey Theatre

The Wolsey Theatre located on Civic Drive was first opened in 1979 by HRH Princess Alexandra. The Wolsey Theatre Company, who originally owned the theatre for twenty years, ran it almost exclusively as a theatre that produced its own shows in-house, presenting performances of drama, comedy and musical plays. However, due to financial difficulties the company folded in 1999 and the building remained unoccupied for two years. In 2001, the venue was reopened as the New Wolsey Theatre by a newly formed company, which has continued to produce many shows in-house, while also hosting touring theatre companies and other events such as comedy nights. Since its reopening, the New Wolsey Theatre has become an excellent example of Ipswich's cultural offer. For a mid-sized regional theatre with 400 seats, it certainly punches above its weight as a national leader recognised for the diversity of its audiences and performers. The theatre is also particularly noted for the development of its own recognisable house style of actor/musician productions, perhaps most notably in their ever-popular annual rock 'n' roll pantos, but is also something the company has also carried over into other popular productions, including a recent retelling of the story of Ipswich Town winning the FA Cup in 1978 in the play *Our Blue Heaven*.

New Wolsey Theatre.

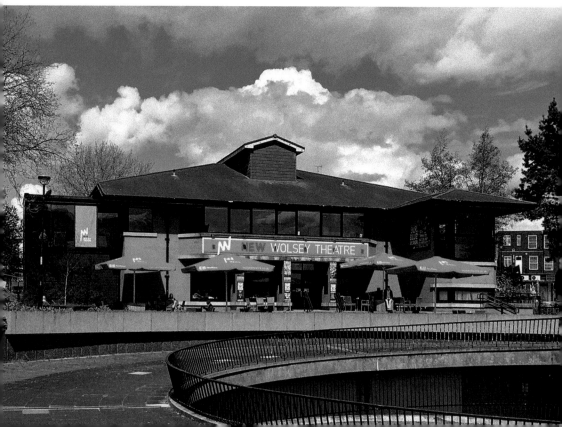

12. Gippeswyk Hall

This red-brick building, constructed around 1600 as a farmhouse, was originally owned by the Knapp family. Gippeswyk Hall was then surrounded by farmland and quite separate from Ipswich. This changed during the Industrial Revolution, particularly with the arrival of railways to Ipswich in the mid-1800s. A population boom followed that saw Stoke grow from a community of hundreds to a suburb of thousands that eventually enveloped Gippeswyk Hall. Perhaps its most notable resident was Sir Alfred Garrod MD (1819–1907), who, after a period of apprenticeship to a local surgeon, went on to study and teach medicine in London. He helped categorise and coined the term for 'rheumatoid arthritis', and was elected a fellow of the Royal Society and president of the Medical Society of London. He was also appointed 'Physician Extraordinary' to Queen Victoria in 1890. During the First World War, Gippeswyk Hall Hospital was established upon the site as an isolation hospital for measles. Since then, the building has seen several commercial uses. In 2010 the Red Rose Chain theatre company took over the building. They were then successful in applying to the Heritage Lottery Fund for funding to develop a new theatre on the site next to the hall. Work began in 2013, and the resulting Avenue Theatre opened in 2015.

Gippeswyk Hall.

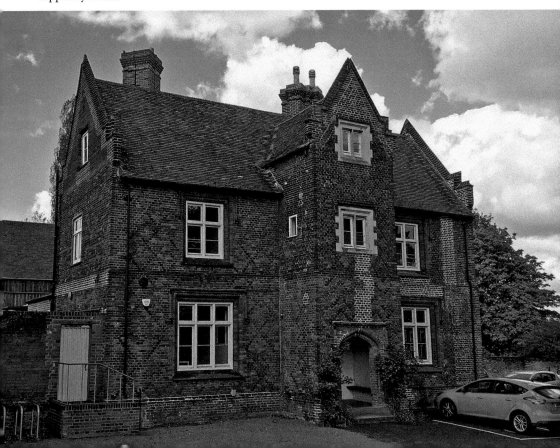

13. Regent Theatre

The Regent opened in 1929, originally as a cine-variety hall – a theatre that showed films as well as hosting live acts. Due to the popularity of cinema in the 1930s and 1940s, other film-showing theatres popped up around town. By the late 1930s, as well as the Regent, there were another five to choose from: Poole's Picture Palace in Tower Street, the Central in Princes Street, the Ritz in Buttermarket, the Picture House in Tavern Street, and the Odeon in Lloyds Avenue. Unfortunately, this level of enthusiasm for film took a hit in the 1950s as television developed a mass audience and many people decided to stay at home and watch the small screen instead of going to the cinema. This proved to be a testing time for cinemas across the country. The Regent (at this time called the Gaumont) answered this challenge in part by converting its upstairs restaurant into a Victor Sylvester Dance Studio in an attempt to increase profits.

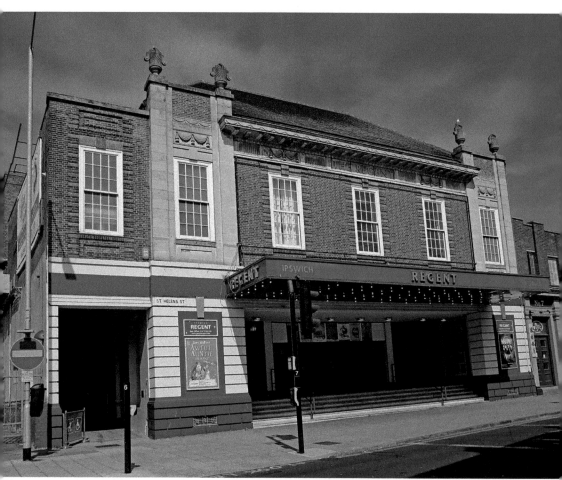

The Regent Theatre.

In doing so it became one of the most popular places in the town with young people looking for an excuse to mingle with the opposite sex. At the end of the 1950s, with the arrival of rock 'n' roll and pop music, the Gaumont began to find a new role as one of the leading live-music venues in the region, hosting some of the biggest names in music in the decades to come, including Buddy Holly and the Crickets, Little Richard, the Beatles, the Rolling Stones, Tom Jones and Tina Turner. In 1965, the proprietors (the Rank Organisation) invested £50,000 in modernising the venue, but sadly by the 1970s cinemas with large screens and auditorium spaces were becoming less economically viable. Plans to turn the auditorium into a multiscreen complex were abandoned as it was considered the only local venue capable of putting on large-scale live shows and concerts. The theatre was eventually purchased by Ipswich Borough Council, who relaunched the Regent in 1991 as part of their arts and entertainment portfolio. Today, the Regent continues to host musicals, comedy acts and live music as well as an annual Christmas panto.

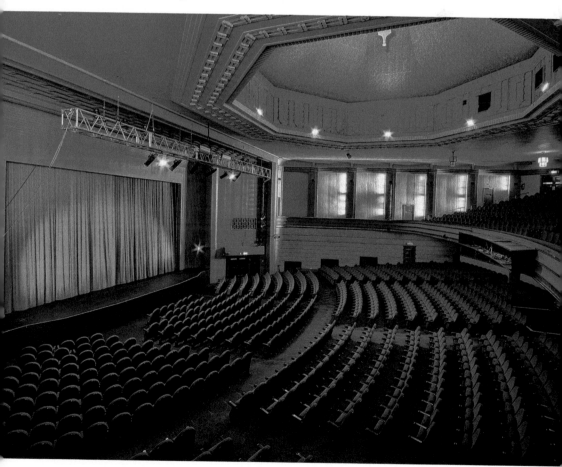

The Regent Theatre auditorium. (Courtesy of Ipswich Borough Council)

14. Portman Road Stadium

The Ipswich Association Football Club was founded as an amateur club in 1878, and on 15 January 1884 they played their first match at Portman Road. In 1888, Ipswich Association agreed to merge with Ipswich Football [Rugby] Club to form the Ipswich Town Football Club. Although there was little in the way of ground improvements at that time, Ipswich became one of the first teams to use goal nets in 1890. Play was suspended during the First World War, during which time the army took over the site to use as a training camp. After the war, the club tried whippet racing as an extra source of income and, according to at least one source, a groundsman kept chickens, goats and sheep in the stand. The club finally became a professional team in 1936 when it was elected to the Southern League and the first professional footballers were signed to the team; it was also in this year that the first

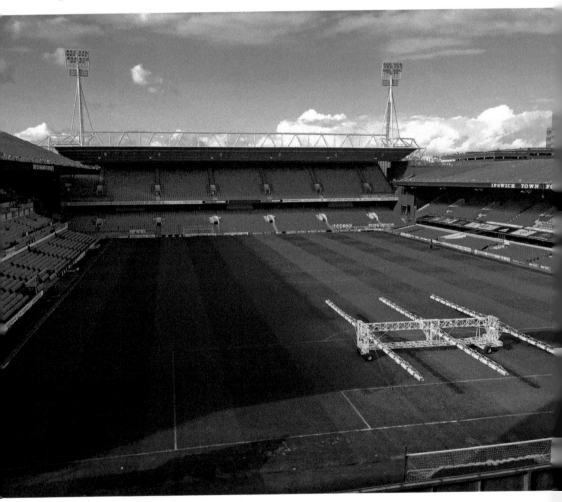

Above and opposite: Portman Road Stadium.

bank of terracing was built. Play at Portman Road was then suspended once again during the Second World War. However, once the war was over, the Supporter's Association funded big improvements at the ground, with new terracing built and floodlights installed. The club really sprang to prominence under the management of Alf Ramsey when they won the Second Division in 1960–61 and the First Division Championship in the following season. Bobby Robson was appointed in January 1969 and did not have an easy start, but once he had stamped his mark on the club they achieved great success – perhaps most impressively with the winning of the FA Cup in 1978, 100 years after the amateur club had been formed. During these decades many alterations were continuing to be made to improve and extend the stands. After the team's promotion to the Premier League in 2000, and the windfall from broadcasting that brought with it, investment was put into updating the stands and improving the capacity to a little over 30,000 seats. The Sir Alf Ramsey Stand and the Sir Bobby Robson Stand at Portman Road continue to commemorate these two most successful managers of the club.

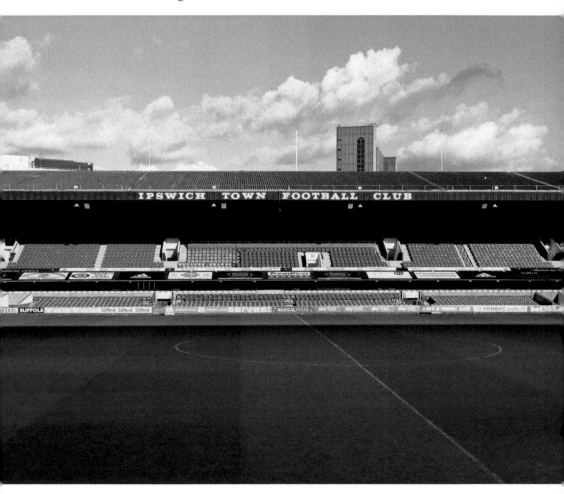

15. Freemasons Hall

Freemasons in Ipswich originally met at various local inns, but in 1870 they moved into their own Masonic Hall between St Stephens Lane and Upper Brook Street (the present-day Conservative Club). The organisation then moved to a new building on Soane Street in 1879, where they have remained ever since. There is much to admire inside, including stained-glass windows fronting the building's first floor, a fine staircase and fireplace. There is also a dining hall with impressive wood panelling and chandeliers. It is the custom of Freemasons to dine following their meetings, which appears to be a tradition that has its roots in their earlier use of inns as meeting places. Upstairs is a very fine example of a traditional masonic temple. Although it is referred to as 'the temple', it is not in fact a place of worship but rather where local masonic lodges meet. The temple's impressive furnishings include a superb carved mahogany Chippendale-style chair, which the master occupies while presiding over lodge meetings. The chair is decorated with various masonic symbols and is thought to have been donated in 1858. This Grade II listed building is often open to the public free of charge on Heritage Open Days.

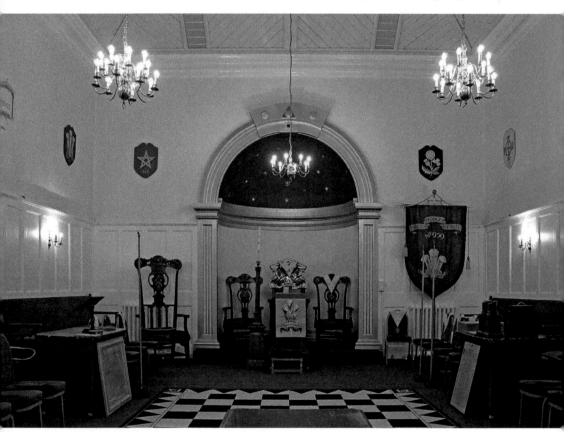

The temple inside the Freemasons Hall.

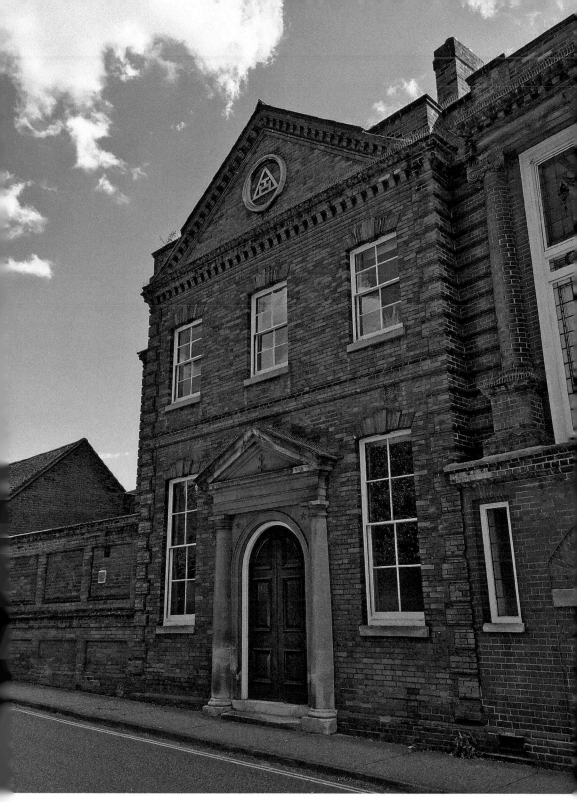

The Freemasons Hall.

16. Willis Building

The Willis Building was opened in 1975 and is one of the first buildings to be designed by Norman Foster. It was commissioned to be the country headquarters for the insurance company Willis Faber and Dumas, as the organisation was then known. The structure was almost immediately heralded as an architectural gem of innovation that challenged the accepted norms for office buildings. It was conceived as a building that at once embraced new technologies and pushed the use of materials to their then limits, while maintaining a respect for its surroundings. The design was particularly recognised for innovations such as bringing escalators into a three-storey office space, while providing a swimming pool and rooftop restaurant and garden, which were designed to help democratise the workplace and encourage a sense of community. The exterior also curves in response to the shape left by previous buildings laid out along the medieval street pattern of

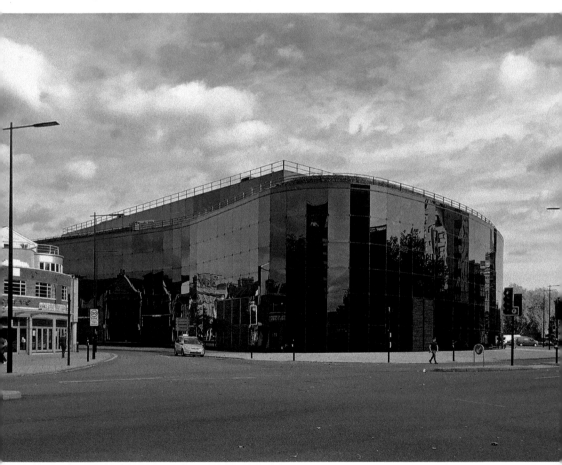

Above and opposite: The Willis Building.

the town. The pioneering use of a glass curtain wall allows for an exterior that appears almost solidly black and reflects the surrounding historic buildings during the day, but then becomes transparent when it turns dark, revealing a lit interior by night. The Willis Building is certainly the most influential piece of architecture to have been built in Ipswich in recent times, having received several high-profile awards for architecture and energy efficiency. In 1991 the Willis Building was the youngest building to be awarded Grade I listed building status in the country and remains one of the youngest so rated to this day. Although the radical design might not have been initially greeted with universal approval in Ipswich, over the years the Willis Building has certainly come to be seen as an impressive asset to the town's architecture. The company that owns the building has had several mergers and changes of name since 1975 and so the building has also been technically known by several different names. I record it as the Willis Building here simply because that is how most people who live in the town today still refer to it.

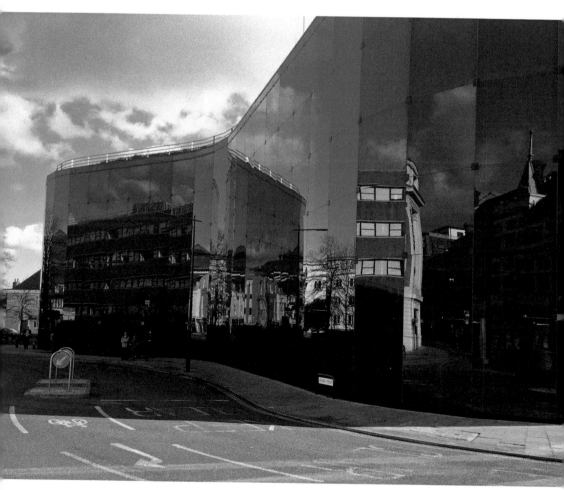

17. Old Custom House

The name Old Custom House can lead to a little confusion, as the current building is actually built on a site that had already been used as a place of civic administration and customs for centuries before its construction. A much older, sixteenth-century, timber-framed custom house was replaced by the current building in 1844–45. In the twentieth century this building then became known as the 'Old' Custom House. The original building had an attractive colonnaded front, complete with ornately carved depictions of lions and unicorns on the woodwork (to symbolise England and Scotland), which sailors could shelter under while waiting at the quay. This structure was in poor condition by the nineteenth century and was taken down in 1843 to make way for its replacement. Fortunately, some of the fine timber was saved and remains in the

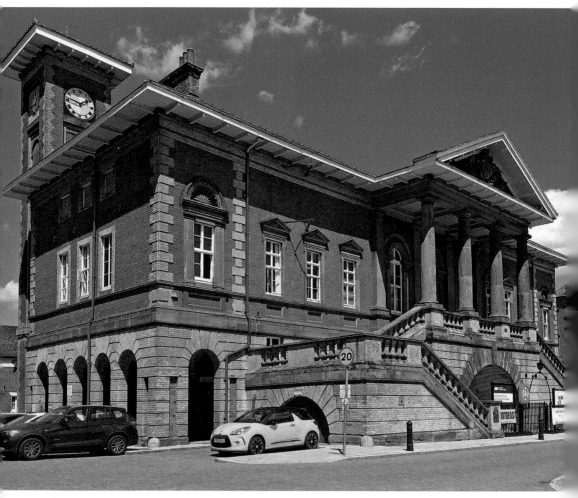

Above and opposite: Old Custom House.

care of Ipswich Museums. The current building was planned in order to handle the expected increase in trade that would result from the impressive 33-acre wet dock, which was completed in 1842. The building was designed by John Medland Clark, a local architect, and is an early example of red brick being used for an important public building, which has contributed to it now being Grade II listed. If you look up at the pediment supported by columns you can see that it includes an impressive three-dimensional version of the Ipswich coat of arms. The blue doors, within the quarter-sphere stonework on the ground floor, were once used to take prisoners into the police station that was also housed within the Custom House, and it is still possible to see former cells inside the building today. The Custom House was the headquarters for the Ipswich Dock Commission and then the Ipswich Port Authority before coming under the control of Associated British Ports. The Custom House remains a working building and is not ordinarily open to the public; however it does usually take part in the Heritage Open Days each year, when members of the public are able to take a look inside.

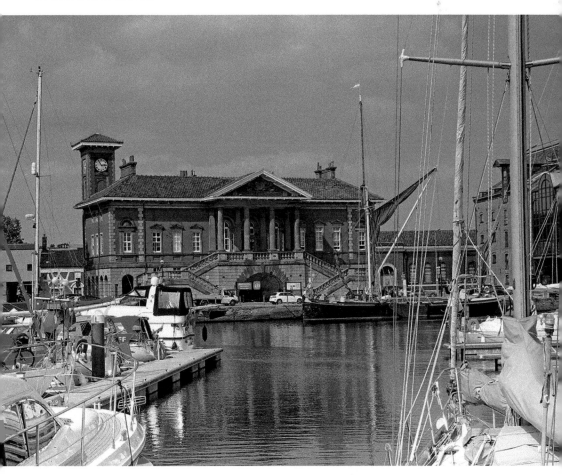

18. Tooley's Court

Tooley's Almshouses were originally built on Foundation Street in the 1550s. In fact, it was these almshouses, together with Christ's Hospital that once stood nearby, which gave the street they stood upon its name. The two separate establishments were often collectively referred to as 'the foundation' as both were set up to serve the poor and needy of the town. The almshouses were first established by a bequest of Henry Tooley, one of the wealthiest local merchants of his day, after his death in 1551. All of Tooley's three children had sadly died before reaching adulthood and, without many near relatives, he decided to leave much of his fortune to the people of Ipswich. One of Tooley's bequests was for the setting up of almshouses for ten ex-soldiers who had fought in the king's wars and were disabled in some way as a result. If ten such people could not be found in the town then the places were to be given to aged and

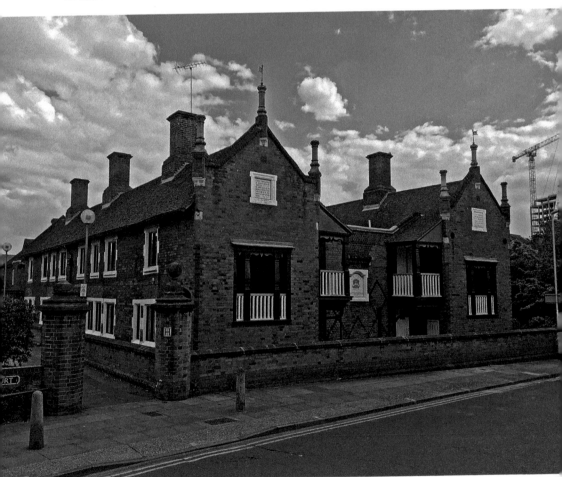

The Victorian rebuild of the almshouses.

decrepit persons instead. In due course, five houses, each to house two people, were built. When William Smart, another wealthy local, died in 1599 he too left a considerable bequest to help the poor of the town and this became added to the Tooley foundation, and the properties became known as Tooley's and Smart's Almshouses. By the seventeenth century, with the establishment of Christ's Hospital and the almshouses, it appears Ipswich was looking after its poor better than many other towns and cities in England. The almshouses were rebuilt in 1846 on much the same site but to an improved standard, and these red-brick structures now surround a pleasant courtyard. On two of the street-facing properties inscriptions dedicated to Tooley and Smart can still be read: 'In peaceful silence lett Toolie rest; Whose charitable deeds bespeak him blest' and 'Lett gentle Smart sleep on in pious trust; Behold his charity, respect his dust'. The almshouses are still in use today as Tooley's Court, offering sheltered accommodation to people over the age of sixty.

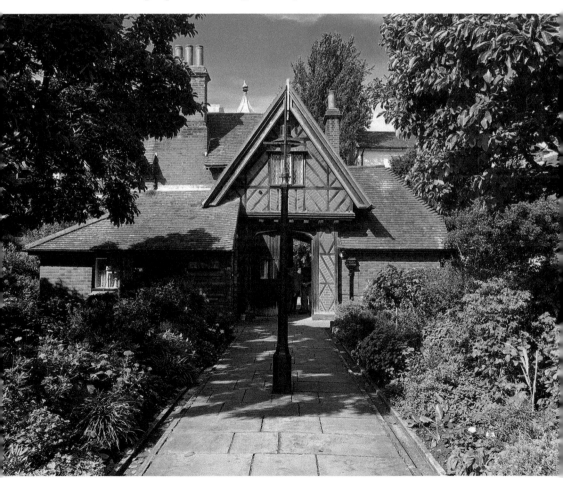

The courtyard of Tooley's Court.

19. Ipswich and East Suffolk Hospital

The Ipswich and East Suffolk Hospital, situated between Ivry Street and Anglesea Road, was opened in 1836 after being paid for by public subscription at a cost of £2,500. It originally comprised a single two-storey building with fifty beds, but a third storey was added in 1869. The First and Second World Wars brought increased demand, so the facility was extended to accommodate 100 beds. After the First World War a new wing was built at a cost of over £50,000, which was again raised by public subscription, and further improvements continued to be added to the site over the years. In 1948 the hospital became part of the newly formed National Health Service. Eventually the use of this building as a hospital was superseded by Ipswich Hospital on Heath Road. The Ipswich and East Suffolk Hospital then became known instead as Ipswich Hospital, Anglesea Road Wing, and stopped serving as the main hospital in 1955, although it continued in a supporting role until finally closing in the early 1980s. The former hospital found a new use, in keeping with its history as a place for people to receive care, as the Anglesea Heights nursing home until it closed in 2018. The building has recently been bought for development by Ipswich School.

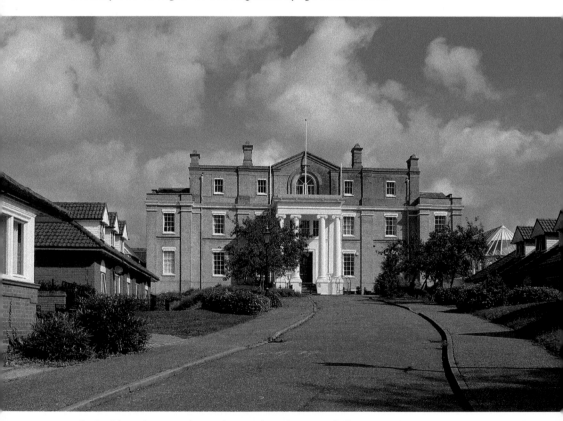

The building that once housed Ipswich and East Suffolk Hospital.

20. Sailors' Rest

Sailors' Rest, situated on the corner of St Peter's Street and Cutler Street, was built around 1700 and for a long time was a privately owned house. It gained its distinctive name from being a hostel, canteen and club for sailors from 1925 to 1957, which is recorded as being owned by the British and Foreign Sailors' Society. Unfortunately, the well-meaning use of this building as a hostelry for sailors for several decades seems to have led to substantial damage of the building's interior, including to an elegant staircase and marble fireplaces. After the building became vacant, a prolonged debate about the future of the building took place during the 1960s after it was proposed that the building should be torn down and replaced with an office block. Even the sculptor Bernard Reynolds wrote a letter, published in the *Ipswich Star*, in defence of the Sailors' Rest. Some of those campaigning for its protection from demolition argued that it was the finest example of William and Mary-style architecture to survive in Ipswich. Eventually the argument to save the building prevailed and restoration work was carried out instead. This Grade I listed building now houses a beauty salon.

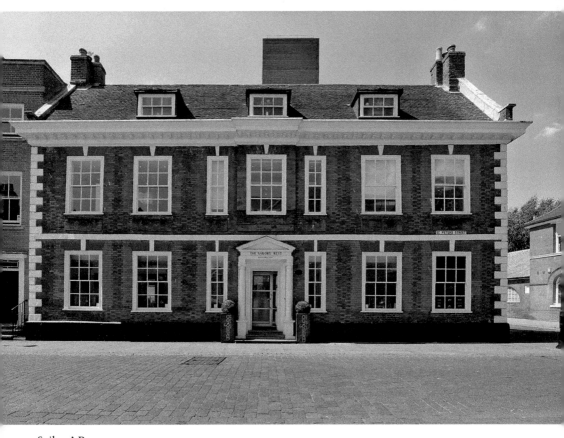

Sailors' Rest.

21. Curson Lodge

This fifteenth-century timber-framed building known as Curson Lodge stands at
the corner of St Nicholas Street and Silent Street and is one of the finest-preserved
buildings from the late medieval period in Ipswich. Curson Lodge took its
name from Curson's House, which once stood across the street and was a more
impressive affair altogether. Curson's House, built around 1500, was occupied by
Lord Robert Curson and was grand enough that Cardinal Wolsey asked to use it
for his retirement home. Curson, not in a position to refuse the cardinal, asked in
1529 for three years' grace to find a new place to live. Shortly afterwards Wolsey
fell from power and Lord Curson got to keep his home. It is thought that the lodge
was used to accommodate the entourage of Lord Curson's high-status guests.
While it is unfortunate that Curson's House no longer exists, the lodge remains
a fine building with an interesting history of its own. It was probably originally
used as a merchant house and shop or an inn. It certainly would have been well-
placed to accommodate visitors who arrived by river to the nearby quayside.

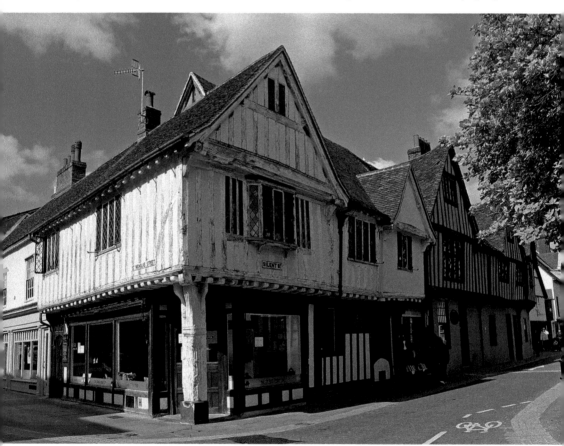

The corner of Silent Street and St Peter's Street.

The building is said to have been used as an inn during the eighteenth century and into the early nineteenth century. From 1838, William Silverston set up a chemist shop in the building and the junction itself was known as 'Silverston's Corner'. Although the business changed hands, the building remained a chemist's for over a hundred years. The site then found numerous other commercial uses until becoming vacant in the mid-1990s. By 2007 a chimney stack at the building's centre was near to collapse and restoration work was undertaken to repair the structure. After restoration the ground floor became shop space and the upstairs was turned into flats. An interesting reminder of the building's past as a chemist came about in 2013 when a car crashed into the entrance of the building and dislodged a medicine bottle from the brickwork. It was found to contain a receipt and business card dated 1902, and records the signatures of the workmen who had carried out some building work at the time.

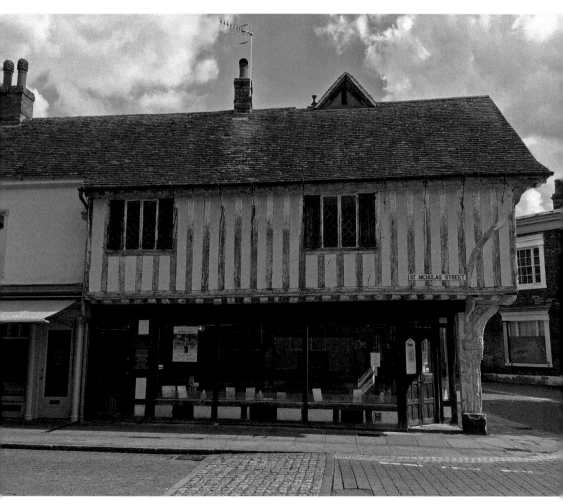

Curson Lodge.

22. Pykenham's Gatehouse

This Grade I listed building was originally constructed to serve as the gatehouse for the Ipswich residence of the Archdeacon of Suffolk, William Pykenham. Pykenham was born in the mid-fifteenth century and studied at Oxford and Cambridge before entering the Church. In the early 1470s he was named Archdeacon of Suffolk and began holding an ecclesiastical court at the church of St Mary-le-Tower, very near to his residence in the town. Upon taking up a new residence in Ipswich he decided his home was too small and set about enlarging it. This work included building an impressive gatehouse facing out onto Northgate Street, which was constructed out of brick (then a fashionable material and a sign of wealth and refinement), as well as a timber frame with wattle and daub infill. This gate is larger, grander and older than the much-noted Wolsey's Gate on College Street, but is much less well known in the town. Perhaps this is because a lot of the fine work on Pykenham's Gatehouse

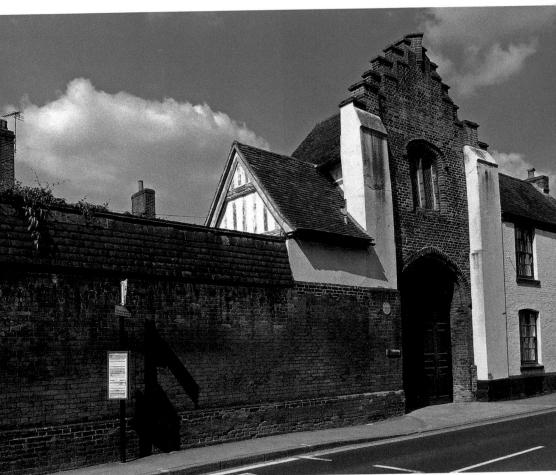

Above and opposite: Pykenham's Gatehouse.

is more noticeable from behind the wall, which townspeople do not normally get to see. The room above the gatehouse entrance, which you can gain a much better view of from behind the walls, was once probably used as a store for important documents or as the archdeacon's library. Today, little is left of what was once the archdeacon's residence. The gatehouse and some of the boundary wall have survived; however the building that originally stood within the walls was rebuilt in the eighteenth and nineteenth centuries, but probably still retains some of the earlier structure within it. The house remained a private residence for many years before becoming the home of the Ipswich and Suffolk Club, a private members' club. The Ipswich and Suffolk Club also own Pykenham's Gatehouse and lease it to the Ipswich Building Preservation Trust, which carried out restoration work on the building in the early 1980s. The gatehouse is normally closed to the public, but is usually open on Heritage Open Days in September each year, when it is possible to view inside the room above the gate.

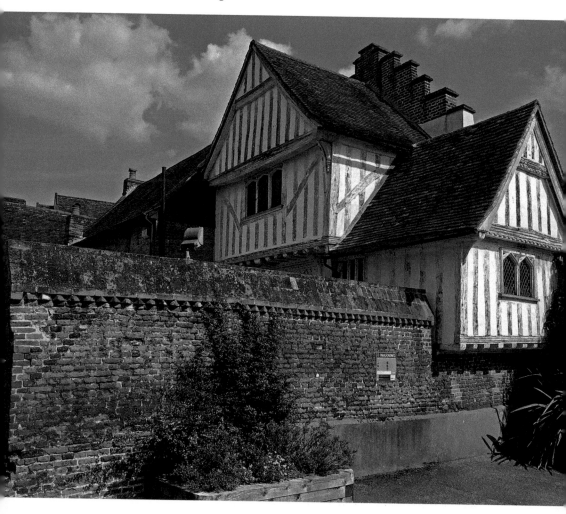

23. Ancient House

One of Ipswich's most celebrated buildings, Ancient House was originally a family home, but over the years it has also been a place of business for fishmongers, booksellers and printers. The current building dates back to at least 1567, but it is thought that some portions of the structure date back to the 1400s. Ancient House was once also referred to as 'Sparrowe's House' on account of it coming into the possession of Mr Robert Sparrowe in 1591 and remaining in the care of his family for around 300 years. There is a story that Charles II was hidden in the house during the English Civil War, but there is no definitive evidence to prove this, and it would seem a risky strategy considering Ipswich in general was very supportive of the opposing Parliamentary forces. Whatever the truth of this story, the Sparrowe family did place the royal arms of Charles II above the doorway in celebration of the Restoration of the Monarchy in the 1660s. The seventeenth-century frontage was made using a

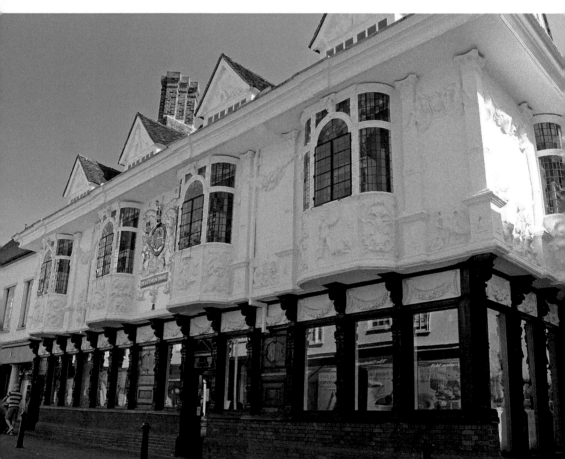

Ancient House.

form of decorated plasterwork called 'pargetting' that was particularly used in East Anglia. Among other things, the designs depict scenes from the world's four then known continents: Africa, America, Asia and Europe (Australia and Antarctica were not yet known to England). Perhaps the most intriguing part of the building's history was the discovery in 1801 of an apartment in the loft that had been closed off and forgotten for a very long time. When first entered, some wooden angels and other figures such as might decorate a Catholic place of worship were found, and so presumably this was a secret chapel made use of during the Reformation. Ancient House is also the best place to see 'Ipswich windows' – a type of oriel window that projects out from the upper floor of a building with a specific design of glazing bars. This term seems to have been coined by architectural historians due to this building featuring such a fine example. Today, the Ancient House is a Grade I listed building and is home to a branch of Lakeland, a kitchenware shop.

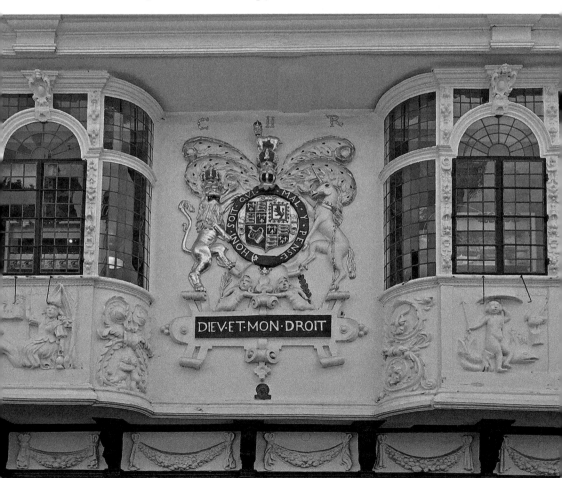

A fine example of 'Ipswich windows'.

24. Manor House

Not one but two of Ipswich's more notable historic characters spent time in this house on St Margaret's Green. The first was Nathaniel Bacon, who lived here from 1642 to 1660 and was an important political figure in Ipswich during the mid-seventeenth century, being both Ipswich's leading lawyer as the town's recorder, as well as its Member of Parliament. He also put together his *Annalls of Ipswiche* from reading the Corporation records, creating an early history of the town. This was also the house occupied by the Cobbold family and their servant Margaret Catchpole in the late eighteenth century. Catchpole's adventures are too expansive to relate here in detail, but included stealing a horse from her employers to ride to London, being imprisoned in Ipswich Gaol, escaping imprisonment, being recaptured and sentenced to death, and eventually being transported to Australia. It seems that Margaret lived a more respectful and quiet life after arriving in Australia, but her escapades have entered into English legend mainly due to the writings of Revd Richard Cobbold (son of her former employers), who wrote a semi-fictionalised novel called *The History of Margaret Catchpole*. The house itself is a large timber-framed structure and is a Grade II listed building. Today, Manor House retains its name but is now rented out as office space.

Manor House.

25. St Helen's Church

St Helen's is a flint and stone church situated to the east of the town centre and would have stood outside the medieval ramparts that once encircled the town. A church dedicated to St Helen has stood here for around 900 years, but what is seen today was mostly altered and enlarged during the nineteenth century, at which time St Helen's stood within an area with tightly packed terraced streets and small factories, which were mostly removed during slum clearance after the Second World War. All that now remains of the earlier medieval building is the south porch and the south nave wall. In 1875 the old tower was replaced by the present structure, which has a spire that now reaches around 80 feet high. The interior was modernised in the 1980s to suit the needs of the congregation, but some older features remain intact, including a medieval door and some Victorian windows. Although it's unfortunate much of the ancient fabric of this building is lost, it's actually been Grade II listed – partly due to the evidence of subsequent phases of alteration that have taken place. St Helen's remains a place of worship within the Church of England and is run, along with Holy Trinity and St Luke's, as one of the 'Waterfront Churches'.

St Helen's Church.

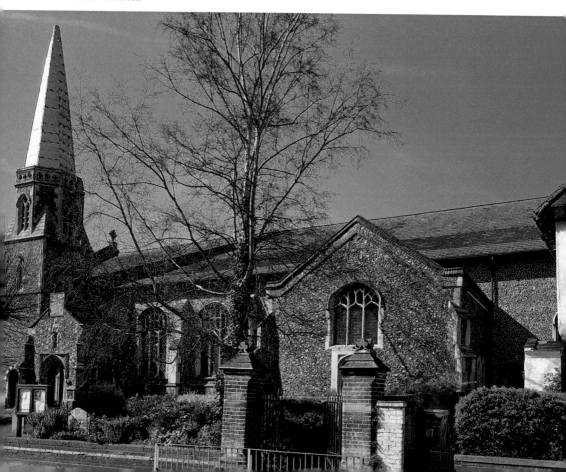

26. St Mary-le-Tower Church

The first church located here was probably constructed with wood and was recorded in the Domesday Book, so must have been standing by 1086. In 1200 the people of Ipswich gathered in St Mary-le-Tower's churchyard to receive their town charter from King John, which was one of the earliest royal town charters in English history. This was an important moment in Ipswich's history as medieval town charters helped make inhabitants more 'free' by lifting them out of the feudal system compared to many who lived in the countryside as serfs. The charter also gave the men of the town the ability to elect officials to look after their interests. We know that by 1200 the original building had been replaced with a more substantial Romanesque church because its image was featured on a borough seal created in that year. By the middle of the fifteenth century the church needed rebuilding again and this was made possible by a provision of stone in the will of William Gowty in 1448. The font is an excellent example of the fifteenth-century East Anglia style and is fortunately still in good condition, so that it is still possible to see its carvings, including lions surrounding the bowl. The font seems to have escaped defacement as the carved lions on it did not offend Puritan ideas. Another interesting feature inside is the memorial of William Smarte who died in 1599, which includes the oldest known painted panorama of Ipswich. The painting shows St Mary-le-Tower with a spire, which was subsequently blown down by a hurricane in 1661. The present – fourth – church on this site was almost completely rebuilt upon its old foundations between 1850 and 1880, but has retained some medieval features such as its arcades, a doorway and some fixtures and fittings. The Victorian rebuilders wanted to make St Mary-le-Tower, as the civic church of Ipswich, the largest and grandest in the town. This is reflected in the current tower, with its impressive chequerboard-patterned exterior topped off with a spire at an impressive height of 176 feet. The bells and ringers of this church have been much celebrated – during the late 1800s and early 1900s the St Mary-le-Tower society was the leading twelve-bell company in the country. St Mary-le-Tower remains both a parish church with its own congregation and the civic church of Ipswich.

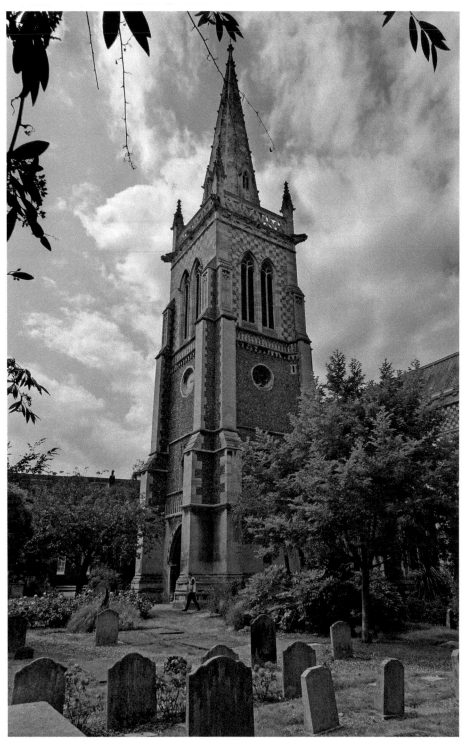

St Mary-le-Tower Church.

27. St Mary at the Elms Church

This is one of Ipswich's medieval churches and was named for the trees that stood nearby. The current church is built on the site of an even older church that was called St Saviour. In fact, the Norman doorway that remains here probably came from the former building and is almost certainly the oldest doorway in Ipswich. According to the church historian Simon Knott, the wooden door with its decorative ironwork that is still used today is as old as the doorway, which would date it to the eleventh century and make it one of the oldest doors still in use in the country. The 54-foot-high red-brick tower with its battlements dates back to the late fifteenth century and is a fine example of its period. Other parts of the church underwent alterations during the Victorian era, including a mainly

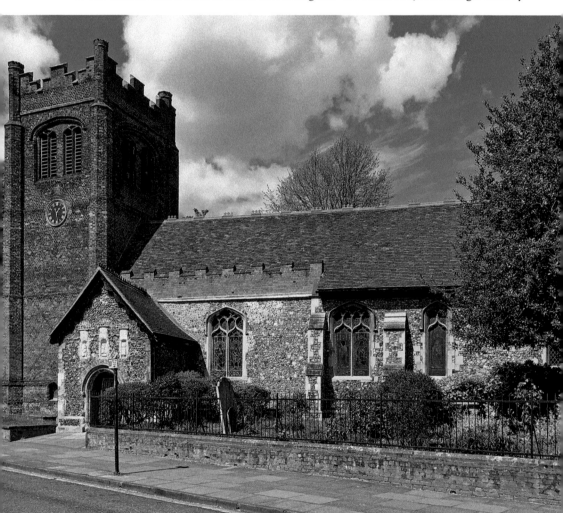

St Mary at the Elms Church.

flint-built extension that took place in 1883. St Mary at the Elms is a church with an Anglo-Catholic tradition. This is perhaps made most clear inside the building, where there is a wooden carved statue of the Virgin Mary with an interesting story behind it. The nearby Chapel of Our Lady of Grace was a well-known medieval site of pilgrimage in Ipswich, which contained a statue of the Virgin Mary. It drew people from across Europe up until the Reformation, including both Catherine of Aragon and Henry VIII, who visited the shrine on separate occasions. After the king's break with Rome, the shrine was sent to London as an example of idolatry to be burned. However, many believe the shrine was in fact saved from the flames and smuggled out of England to Nettuno in Italy, where such a statue is still on display in a church. A replica carved by Robert Malamphy based on the original medieval shrine was placed inside St Mary at the Elms in 2002, and has been visited by people from Nettuno. St Mary at the Elms continues to serve a congregation as a parish church today.

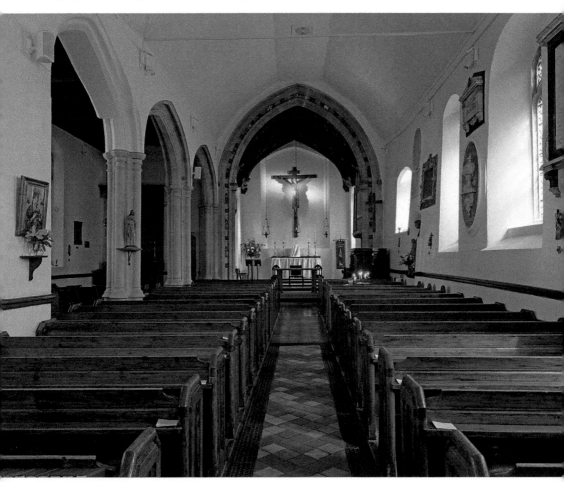

Inside St Mary at the Elms Church.

28. St Mary at the Quay Church

St Mary at the Quay Church dates back to the fifteenth century, with money being provided for its construction in the 1440s and construction beginning around 1450. Being located along the waterfront, many of St Mary at the Quay's early congregation were connected in some way to the trade made possible by the River Orwell. Perhaps the most notable in this regard was Henry Tooley, who was one of the richest merchants of sixteenth-century Ipswich. Tooley left much of his wealth to set up almshouses for the use of disabled ex-soldiers or aged persons that, in a rebuilt and repurposed form, still survive today on Foundation Street. Another person worth mentioning is the explorer Thomas Eldred, who was baptised at the church in 1561 and was a navigator aboard the *Desire* during the second English

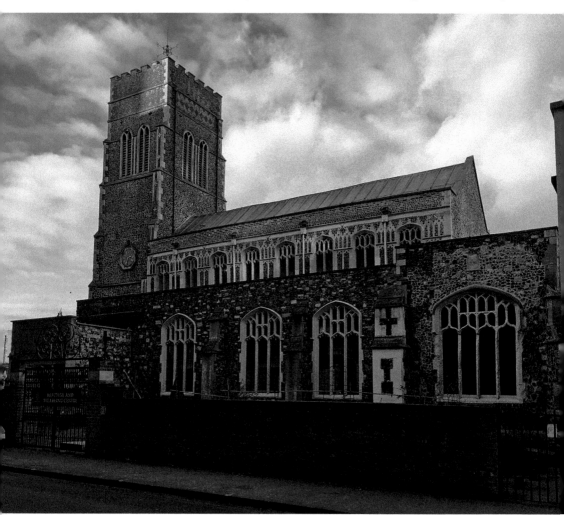

Above and opposite: St Mary at the Quay Church – now Quay Place.

circumnavigation of the globe between 1586 and 1588. St Mary at the Quay enjoyed a long history as a thriving church until more recently when it has been closed and reopened a number of times. In 1898 the building was pronounced unsafe and closed due to repeated flooding, which is also said to have caused an unbearable smell in the vaults. After an appeal for its restoration the church was reopened in 1901. However, a bomb fell just east of the site during the Second World War in 1943, blasting out windows and causing other damage, so the building was again closed. Eventually it was repaired by the Friends of Friendless Churches before being handed over to the care of the Redundant Churches Fund. Inside there is a superb double hammer-beam roof, which features beautifully carved figures of angels and saints, with further carving on the spandrels. There is also a fifteenth-century octagonal font, which includes carvings that represent Saints Matthew, Mark, Luke and John. St Mary at the Quay has had a more positive change in fortunes in recent years as the charity Suffolk Mind and the Churches Conservation Trust have worked in partnership in order to restore and reopen the church as a Heritage Wellbeing Centre called Quay Place.

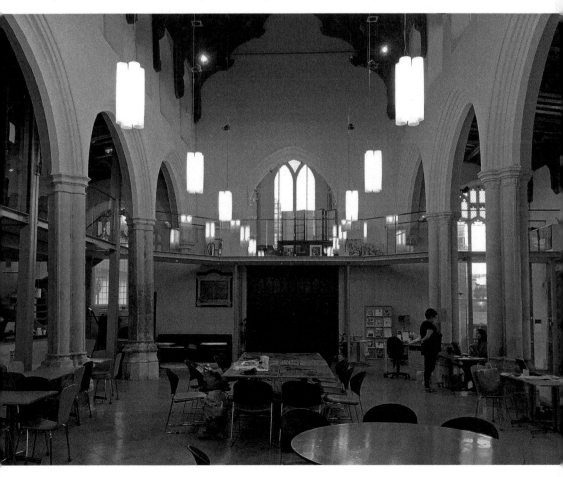

29. St Mary at Stoke Church

The flint and stone church of St Mary at Stoke is the only one of Ipswich's twelve medieval churches that is located south of the river. Stoke was once considered a quite separate place from Ipswich, especially before the construction of the first wooden bridge across the river, which might have been built as early as AD 900. Even when work began on the medieval church in the fourteenth to fifteenth centuries, Stoke was still a small farming community outside the main town, and consequently the church built to serve them was a small one. This all changed with the coming of the railways to Ipswich in 1846, which helped transform Stoke into a populous suburb. The population of Stoke more than trebled in the thirty years leading up to 1871, when an expansion of the church took place to cater for the increasing number of residents. The Victorian extension was designed by William Butterfield, who was one of the nineteenth-century's greatest architects and responsible for

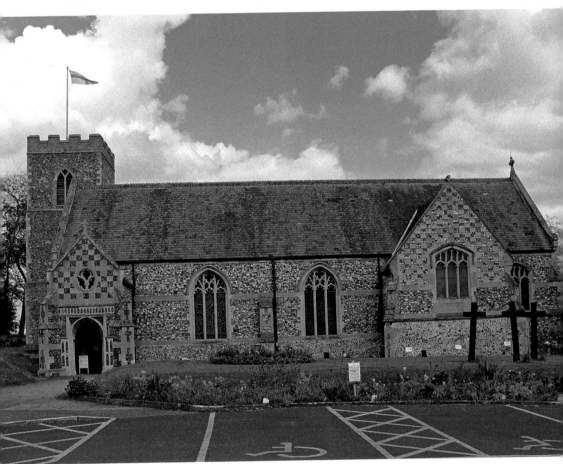

St Mary at Stoke Church.

designing many churches and cathedrals in Britain and around the world. What is now the north aisle of the present building was once the nave of the earlier medieval structure. It still retains its original impressive single hammer-beam roof, featuring many fine wooden carvings, which appears today much the same as it would have done around 1400. An entirely new nave, chancel and south porch were added during the Victorian rebuilding. One of the church's bells dates back to the early 1600s. The other bell (although no date is cast upon it) is attributed to a pair of bell founders who died in the early 1400s, making this even more of a vintage. The tower, at only around 50 feet high, appears a little out of proportion to the rest of the building now, but would have originally matched the smaller church before its nineteenth-century enlargement. After an inspection in 2004, St Mary at Stoke was reclassified as a Grade I listed building, making it one of only two churches in Ipswich with this classification. St Mary's at Stoke remains a place of worship today within the Church of England.

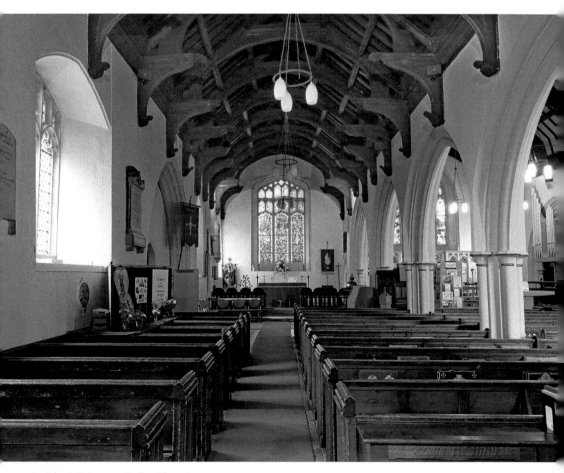

Inside St Mary at Stoke Church.

30. St Lawrence Church

A Church of St Lawrence was recorded on this site as far back as 1086, but nothing remains of that initial building. As St Lawrence Church on Dial Lane is now surrounded by town centre shops and cafés, the first thing you are likely to notice as you approach it is its impressive flint and stone tower with geometric designs and stone carved angels. The current 97-foot-tall tower is the result of a Victorian rebuilding effort in 1882, which was built to encase the remains of the previous fifteenth-century structure. As fine as the tower is, the real treasure of this building is what is contained within it. St Lawrence is home to the oldest complete ring of five church bells in the world. Four of them were cast around 1440–50 and one a few decades later, which is said to have been paid for by Edmund Daundy, Thomas Wolsey's uncle. Wolsey, who would rise from relatively humble origins in Ipswich to become one of the most powerful men in England, second only to Henry VIII himself, would have heard these same bells ring as a youth in the town. The church was named for St Lawrence, who was martyred in Rome in AD 258. He is said to have been roasted on a gridiron and if you look carefully it is possible to see depictions of a gridiron around the building. As people increasingly moved out of the town centre and into the suburbs, St Lawrence, like several other medieval churches in Ipswich, was left with few people living in its parish. The church was closed in 1974 and has been looked after by the Ipswich Historic Churches Trust since it was set up in 1981. The bells stopped being rung after the tower was declared unsafe around the same time. After standing empty for many years, the church was restored and opened in 2008 as the St Lawrence Centre and is now used as a community centre, café and gallery. Additionally, after a fundraising effort, a cast-iron frame was added at a lower level in the tower and the historic bells were rehung on it in 2009. Today upon entering the building you can still see many fine wall monuments from previous centuries dedicated to parishioners of the past, impressive stained-glass windows, and text from the beatitudes found in the Gospels in lettering that dates from the Victorian era that runs around the walls.

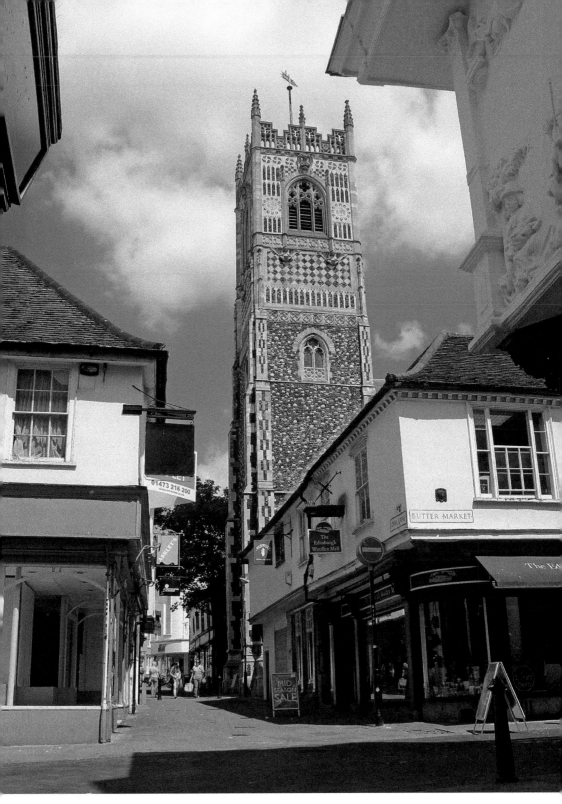

The tower of St Lawrence Church.

31. St Margaret's Church

St Margaret's is considered by many to be the finest medieval church in Ipswich. During the twelfth century, a priory of Augustinian canons was founded nearby, in what is now Christchurch Park, dedicated to the Holy Trinity. Canons based at this priory oversaw the building of St Margaret's in around 1300 to serve the surrounding population. The church houses a fifteenth-century octagonal font, upon the bowl of which was once carved angels bearing scrolls with inscriptions. The angels' faces and inscriptions were scratched from the font in the 1640s by iconoclasts. However, one side of the font was stood against a pillar and mostly escaped defacement, allowing us to read one of the inscriptions, '*sal et saliva*', which refers to the medieval custom of using salt and saliva at baptism. The highlight of this building is the double hammer-beam roof, which is a fifteenth-century masterpiece that

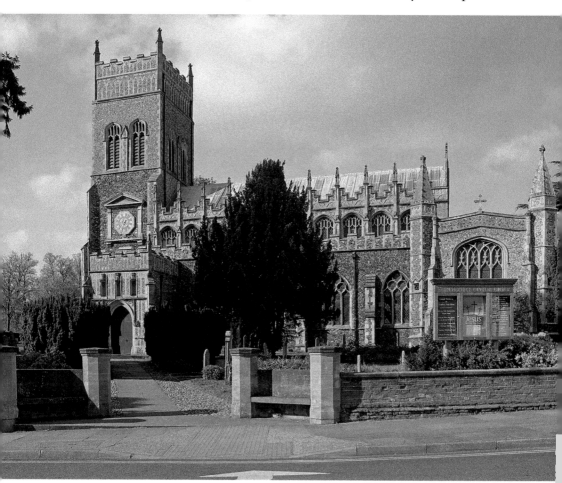

St Margaret's Church.

includes over 120 carvings, as well as remarkable baroque paintings added in the seventeenth century. The church tower was originally added around 1400, but was increased in height in 1871. The attractive blue-faced clock on the tower is one of the oldest public clocks in Ipswich, and was wound by hand before being automated during some works carried out in 2017–18. During the Second World War a bomb fell on St Margaret's Green and blew out much of the Victorian glass, which was subsequently replaced with clear glass, giving the church a brighter feel inside. St Margaret's has eight bells, of which five date back to 1630. In 2017 the church put into action a project with a grant from the Heritage Lottery Fund and other supporters that sought to restore the bells, as well as making the church's heritage more accessible to visitors. After work on the bells was completed they were returned to the church and hung in a new frame lower in the tower. Additionally, a new ringing gallery was installed so that inside the church you can see the ringers as they pull the bell ropes. St Margaret's continues to serve the community as a parish church and has strong links to the nearby St Margaret's Primary School.

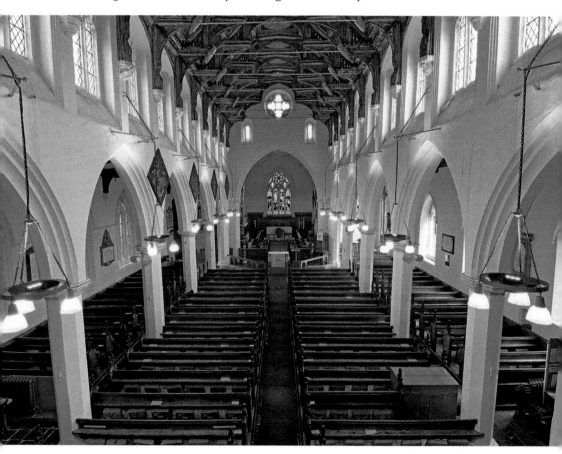

Inside St Margaret's Church.

32. St Clement Church

St Clement Church, situated near the Ipswich waterfront, for a long time associated with mariners and merchants, was often referred to as 'the Sailor's Church'. Indeed, many individuals of significant maritime merit worshiped and are now buried here, including Sir Thomas Slade, who is most notable for designing HMS *Victory*. St Clement is mainly built from flint and stone, with the earliest remaining parts of the church dating from the late fourteenth to early fifteenth centuries. Inside, St Clement Church is rich in memorials, with many dedicated to members of the Cobbold family, who had a long association with the church and were known for their brewing business. The six bells in the tower were all cast by John Darbie, a seventeenth-century Ipswich bell founder. The fine octagonal font is even older, dating back to the fifteenth century. Some alterations were made to the building

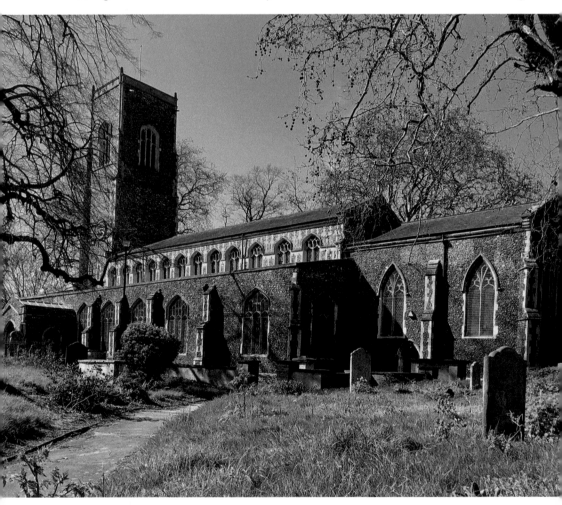

St Clement Church.

by the ever-industrious Victorians, including the rebuilding of the chancel in 1860, after which St Clement remained largely unaltered until being damaged during the bombing raids of the Second World War. In the years that followed the conflict, restoration work was carried out that included replacing the beautiful stained-glass east window, which depicts the Ascension. St Clement became redundant in the 1970s and is now under the care of the Ipswich Historic Churches Trust (IHCT). For many years it was largely left empty, apart from being used for a short time as a prop store for the Wolsey Theatre. After the church was damaged by a fire in 1995, the IHCT put the building back in order by repairing the roof and the tower. In 2018 work was carried out to restore the church's carillon (a type of bell-chiming mechanism that plays notes without the need for bell-ringers, which is rare in the UK), which was originally installed in 1884. There is hope that this beautiful building will soon be open to the public once again, as plans are progressing to transform it into the Ipswich Arts Centre, which will act as a venue for live music and drama as well as a space for rehearsals, talks and other events.

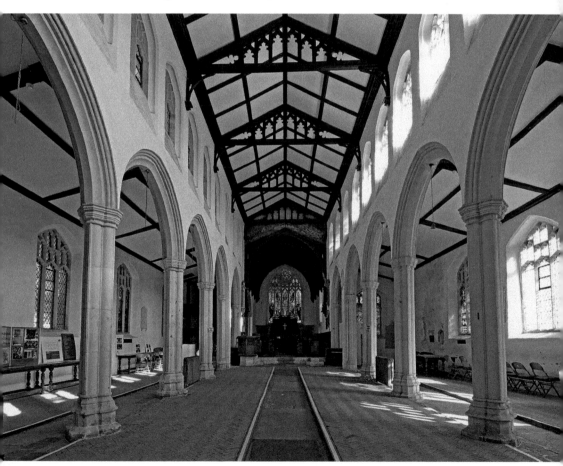

Inside St Clement Church.

33. St Stephen's Church

A church of St Stephen is mentioned in Little Domesday of 1086, although the structure that stands here today was built between the fourteenth and sixteenth centuries. Several building materials have been used in the fabric of this church, including flint, stone and brick. The tower is around 59 feet high and has been patched and restored with red brick. One of St Stephen's more distinguished congregation members was Sir Thomas Rush, who represented Ipswich in the parliaments of 1523 and 1529 and was appointed attorney in the building of Cardinal Wolsey's ill-fated Ipswich College, as well as being a close associate of Thomas Cromwell. On the south side of the church, one of the buttresses, on closer inspection, actually contains a blocked-up doorway. It seems Rush paid for a chapel to be built for his use on the south side of the nave, for which this side door served as the entrance.

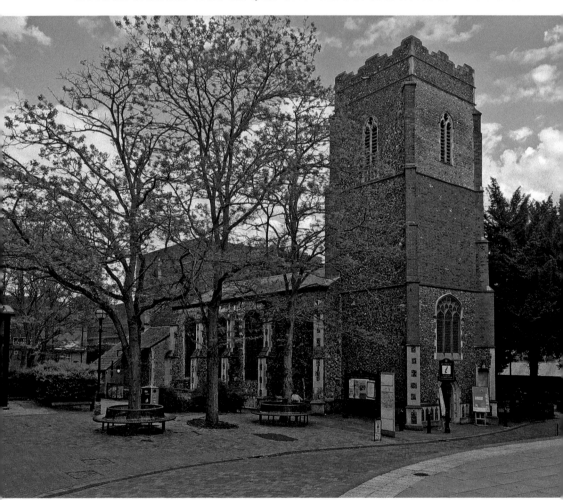

St Stephen's Church.

All that remains now to show his connection to the former doorway is his initial 'T' on one side of the buttress (presumably the 'R' on the other side has worn away over time). Hanging upon a brick wall facing the back of St Stephen's Church is the last known wooden beam from Rush's Tudor house, which once stood in nearby Brook Street. St Stephen's Church closed its doors as a place of worship in the 1970s, but, after a long stretch of redundancy, was restored in 1994. It is now under the care of the Ipswich Historic Churches Trust and has found a successful new use as Ipswich's Tourist Information Centre. The interior continues to house many artistic treasures from Ipswich's historic churches including paintings, memorials and monuments, as well as a collection of hatchments (centuries-old paintings on board that were hung as memorials for affluent men and women). The building retains much of its original character while playing host to the books, guides, keepsakes and other wares of the Tourist Information Centre.

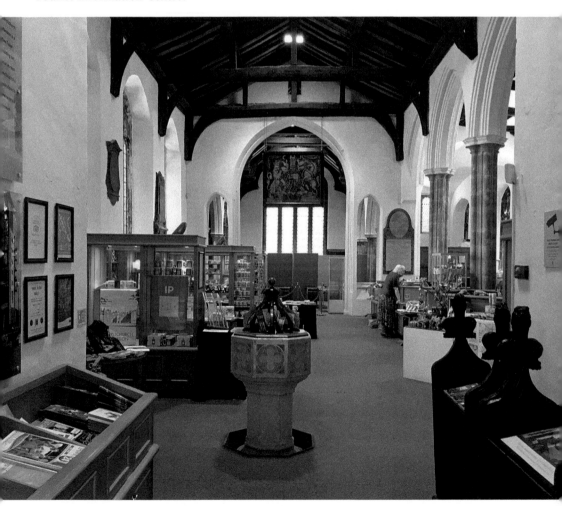

Inside St Stephen's Church – now used as Ipswich Tourist Information Centre.

34. St Peter's Church

A church dedicated to St Peter in Ipswich is mentioned in the Domesday Survey and probably refers to a building on this site. It is thought that this is the first place a church was built when Anglo-Saxon Ipswich was established. If this is true, as Ipswich is considered England's longest continually inhabited town, it would make St Peter's a strong contender for the longest continually inhabited parish in England. The first church that existed here would probably have been wooden and stood on the water's edge, as the river was wider before being tamed by more modern developments. The church was the host of a royal wedding in 1297 when Edward I brought his daughter Margaret here to marry John, Count of Holland. The current flint and stone building dates back to the fifteenth century. St Peter's Church was taken over by Cardinal Thomas Wolsey in the 1520s to be used as the chapel for the grand college he planned for his home town and the parishioners

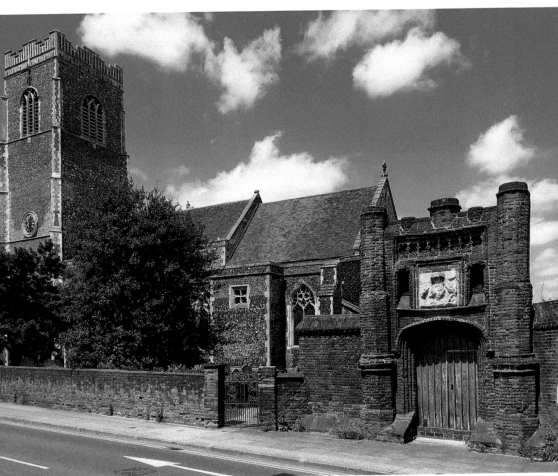

St Peter's Church, next to Wolsey's Gate.

were forced to attend other churches. However, before the building of the college was completed, Wolsey fell from power, work on the site was abandoned, and the former congregation got their church back. The remaining Tudor gateway was only ever supposed to be a side entrance for those arriving to the college by river. Inside St Peter's is another reminder of Wolsey's connection to the church: the impressively rare twelfth-century font bowl made of carboniferous limestone, known as Tournai marble, is one of only a handful in the country and sits upon a Tudor base commissioned by the cardinal. Like most ancient churches in Ipswich, it underwent some rebuilding and restoration work during the Victorian era. St Peter's was in use as a place of worship until 1973 when it was made redundant. The Ipswich Historic Churches Trust took over the care of St Peter's and for a while it was left empty, apart from being used for some time by a model railway club. In 2008 the church was renovated and today it is a heritage centre as well as a concert and rehearsal venue.

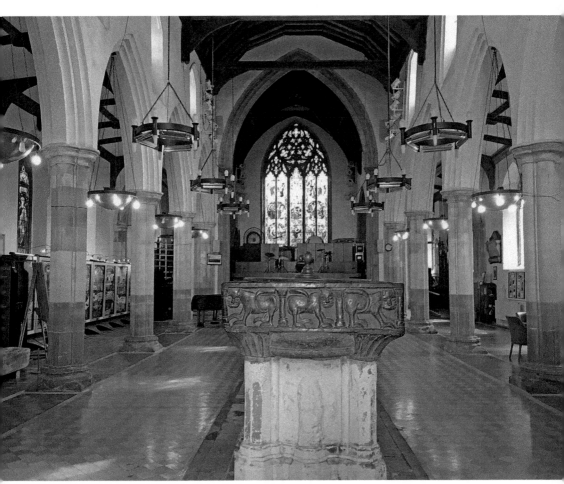

Inside St Peter's Church.

35. St Matthew's Church

St Matthew's is a medieval church located a little to the west of the town centre. The core of the current building dates back to the late fourteenth and fifteenth centuries, but in fact the history of the church predates even this, with St Matthew's first being recorded in the twelfth century. Although it has undergone much rebuilding and renovation, St Matthew's retains its original fourteenth-century single hammer-beam roof, which is decorated with carved wall plates and angels with shields. According to church historian Simon Knott, the font that St Matthew's houses is one of the most significant medieval art survivals in Suffolk, as well as being one of the finest late medieval fonts in England. Sources disagree about exactly when the font was made, but Knott places it during the first few decades of the sixteenth century. The bowl depicts

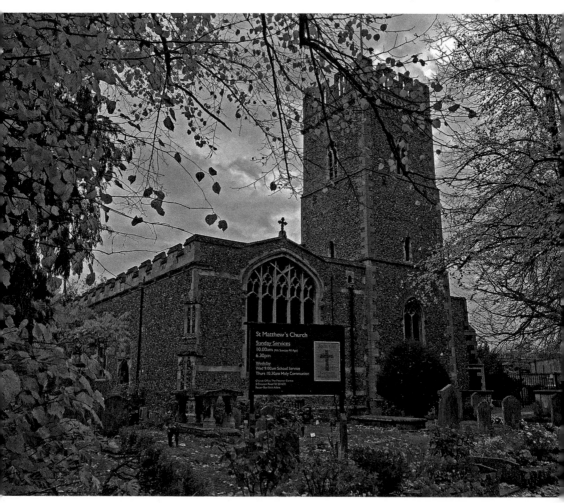

Above and opposite: St Matthew's Church.

the baptism of Jesus as well as scenes from the life of the Virgin Mary. When you consider how much Catholic iconography was destroyed by reformers in the sixteenth and seventeenth centuries in many Ipswich churches, and indeed across the country, the fine state of preservation of this font and its imagery is truly remarkable. In the nineteenth century St Matthew's was known as the town's garrison church due to its proximity to the Ipswich barracks, which was set up on a site between Norwich Road, Anglesea Road, Berners Street and Orford Street. The addition of these military personnel to the church's parish was at least partly responsible for the building's large-scale expansion that took place in phases during that century. The work included rebuilding and enlarging the south and north aisles, building a new south chapel and south porch and rebuilding the east wall and the upper part of the tower. These extensions made St Matthew's one of the largest churches in the town. St Matthew's continues to be a place of worship today as a parish church with links to the nearby St Matthew's Primary School, which has its playground built over what was once part of the church's cemetery.

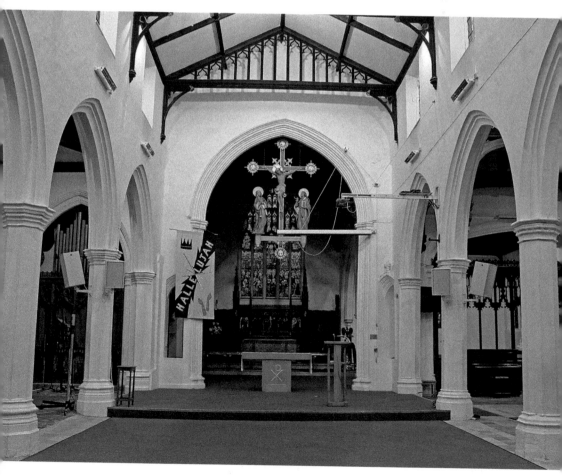

36. St Nicholas Church

The oldest parts of St Nicholas Church date back to around 1300 but an even older church once stood on the same site. It is located along a route between the waterfront and town centre and its fine flint and stone structure, complete with a 57-foot-high tower, is reflected by the dark glass of the nearby Willis Building. Impressive though the outside is, the real treasure is to be found inside the church in the form of some stone carvings that date from the eleventh or twelfth century and so predate the church building itself. These astonishingly rare survivals are the finest examples of Romanesque sculpture known to remain in Suffolk. One carving depicts St Michael fighting a dragon with an Early English inscription: 'HER SANCTUS MICHAEL FEHT WID DANE DRAGON'. Another is a semicircular stone featuring a boar in profile with a Latin inscription: 'IN DEDICATIONE ECLESIE OMNIUM SANCTORUM' ('In dedication of the church of All Saints') and so presumably came from

St Nicholas Church.

an older church of that name. Some argue that this was the church Thomas Wolsey was baptised in *c.* 1473, although there is no definitive evidence of this. His father, Robert Wolsey, was listed as a warden of St Nicholas Church, so at the very least the cardinal would have been familiar with the building. St Nicholas Church was developed and extended over the centuries that followed and, like many other ancient churches in Ipswich, underwent a thorough Victorian restoration. In the 1980s the building became redundant and after it closed as a place of worship it was placed under the care of the Ipswich Historic Churches Trust. The trust looked after it for around twenty years, but it remained mostly unused until the Church of England, which already had offices next door, bought back the building in 2001 for a sum of just £1. A glass atrium was built to connect the church to the offices and it became a resource and conference centre for the diocese of St Edmundsbury and Ipswich, called the St Nicholas Centre.

St Nicholas Church viewed from the roof of the Willis Building.

37. Bethesda Baptist Church

The first Baptist church in Ipswich was Stoke Green Baptist Church, established by a congregation moving from Woolverstone in 1773. This church grew rapidly, with many baptisms taking place in the River Orwell, and soon members were sent to form new churches. The original Bethesda building, which was situated on the same site before the present building replaced it, was one such chapel. It came about after twenty members of the Stoke Green community set off to form a new church and eventually purchased property on Dairy Lane (now Fonnereau Road) in 1829. Within three years they had outgrown their site and decided to enlarge the chapel by erecting a schoolroom and vestry. The congregation continued to grow and the members decided to begin raising money to further extend the building. On 21 March 1906 the foundation stone was laid for a new school hall, and the opening ceremony for this building took place on 27 June that same year. Bethesda became one of the most attended churches in the town – a *Suffolk Times* reporter wrote in 1907 that 'on our first visit on a cool damp Sunday morning the congregation

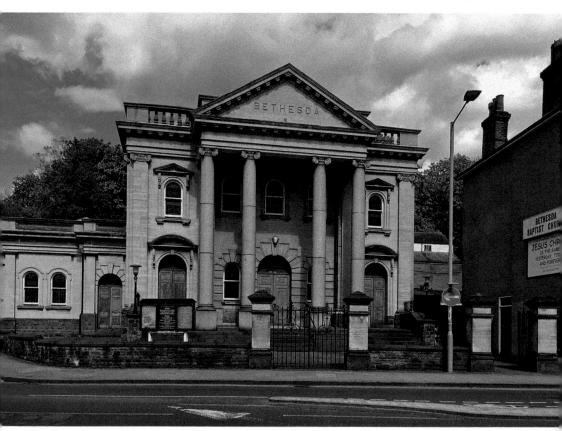

Above and opposite: Bethesda Baptist Church.

numbered about 600'. After the completion of the school hall, the building of a larger chapel was becoming a priority, but the fact that the members decided to install electricity and replace some seating in the building that they already had shows how far away a prospect this must have seemed. This all changed in 1911 when Arthur Page offered to take on full financial responsibility for building a new chapel after attending the funeral of his mother, Susannah Page, who had died at the age of eighty-two after sixty-seven years of membership of the church, saying he would like her name to be permanently associated with the new Bethesda. In July of 1911 the gift was made, in July 1912 the stone-laying ceremony took place, and in July 1913 the work was complete. The entire enterprise cost an incredible sum of money. However, the benefactor did not attend the opening service, but sent a message saying that all the praise should be given to his mother's god.

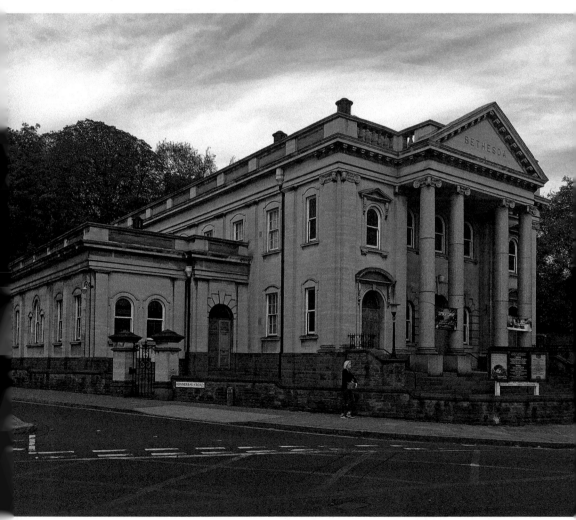

38. Unitarian Meeting House

The Unitarian Meeting House is the oldest surviving timber-framed chapel in East Anglia. It was built in 1699 and opened in 1700. It is a Grade I listed building and one of Ipswich's most historically interesting structures. It owes its existence to the religious turmoil of the seventeenth century, when many new Christian groups formed and split from the Church of England. This congregation, like many others, was founded sometime after the 1662 Act of Uniformity, which excluded from the Church of England those clergy who would not conform – hence the name 'Nonconformists', which came to be given to those who set up new independent congregations. The Act of Tolerance of 1689 encouraged these groups to create

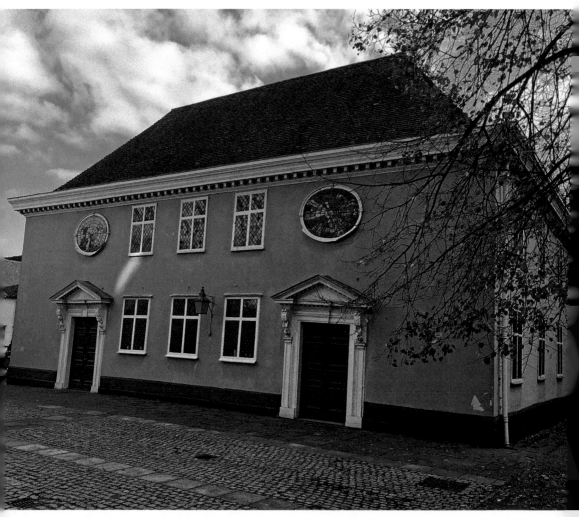

Above and opposite: Exterior and interior of the Unitarian Meeting House.

their own places of worship, sometimes in converted houses or in new purpose-built structures, as in this case. Much of the impressive interior is original, including a spyhole in the door of the east entrance, once used to keep watch for possible hostiles. It reminds us that religious liberty was still not entirely assured when the meeting house was first built. The ornately carved pulpit, reached by a set of fine wooden stairs, is a work of real excellence of craftsmanship and was possibly carried out by Grinling Gibbons, who was considered the finest woodcarver then working in England. The roof is supported by four wooden columns, traditionally said to be ships' masts. It is thought that in the early days of the meeting house, the sexes were segregated – the men downstairs and the women upstairs – in what may have been an echo of traditional Jewish practice. In 1722, the famous writer and traveller Daniel Defoe remarked of the Ipswich Unitarian Meeting House that it was 'as large and as fine a building of that kind as most on this side of England, and the inside the best finished of any I have seen, London not excepted'. The Unitarian Meeting House is still home to a liberal Unitarian community today and is often open for the public to explore free of charge.

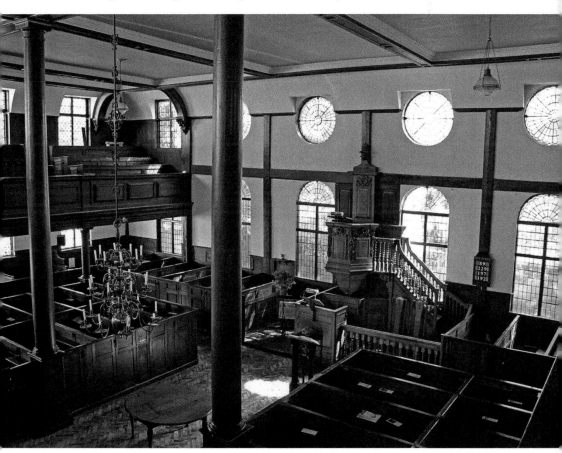

39. Blackfriars Ruins

Little remains of the large Dominican friary that once stood on this site. Dominicans were known as 'Black Friars' for the black cloaks they wore over their white habits. This particular order was founded in Ipswich in 1263 when Henry III bought a property for the friars and then went on to buy more property for them in 1265. The site continued to grow steadily until the mid-fourteenth century, including a huge church around 177 feet long, and maintained a presence in the town until the dissolution of the friary under Henry VIII. The church building was demolished shortly after its dissolution, but the town continued to find new uses for many of the other friary buildings for centuries to come. Part of the complex became the base for Christ's Hospital, which was established by a royal charter from Elizabeth I in 1572. Christ's Hospital was not particularly a religious institution and wasn't really a hospital either. In this case the word refers to a place people could stay (think hospitality not medical centre). It was established to help the needy in

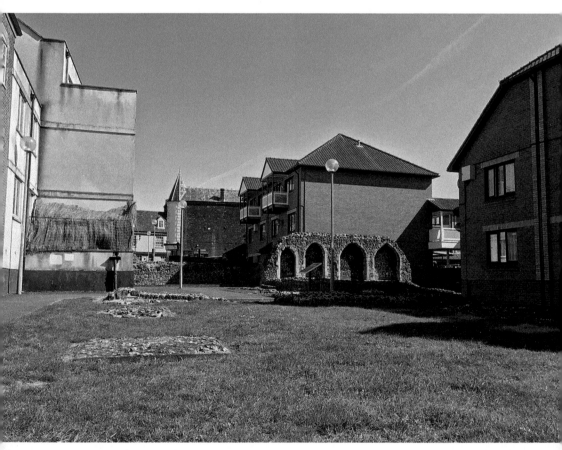

Above and opposite: The ruins of Blackfriars.

Ipswich, as a place of residence for the very young and aged homeless, as well as acting as a school (of sorts) where boys from humble backgrounds would earn their keep by spinning and carding (aspects of the cloth-making industry that was a vital part of Ipswich's economy in the sixteenth and seventeenth centuries). Christ's Hospital's function as a place of instruction for boys eventually became the institution's leading preoccupation at the Blackfriars site until it took up new premises off Wherstead Road in 1841. Samuel Ward, an influential Puritan lecturer persuaded the town to use the northern half of the old Blackfriars dormitory to set up the first library in the town, primarily for his own use as town preacher. Another part of the dormitory was used as a gunpowder and armaments store around the time of the English Civil War. The remaining parts of the Blackfriars site were demolished in the mid-nineteenth century. Housing has now been built over the site, although a fraction of the ruins remain on show.

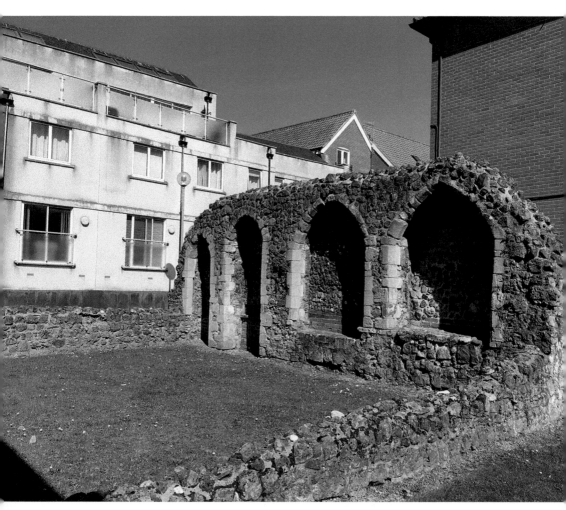

40. Ipswich School

The roots of Ipswich School can be traced back over 600 years, albeit in different buildings and locations, with the first identifiable record being an unpaid bill dating from 1399. In the 1480s the school moved to a house left in the will of a merchant, politician and ex-pupil, Richard Felaw. One of the school's houses is still named in his honour. The school was incorporated into the college set up by Cardinal Wolsey, which was in the process of being built when he fell from power. The school managed to survive as an institution even though the waterfront college buildings were abandoned. Wolsey's ill-fated college is mentioned in Shakespeare's play *Henry VIII* in relation to the Cardinal's fall, which has led some to argue that Ipswich School is the only remaining school to feature in Shakespeare's work. The school takes its coat of arms and motto – *Semper Eadem* ('Always the Same') – from Elizabeth I, who confirmed the charter that had first been given to the institution by her father Henry VIII. Sometime between 1612 and 1614 the school moved to part of the former Blackfriars site on Foundation Street, where it remained

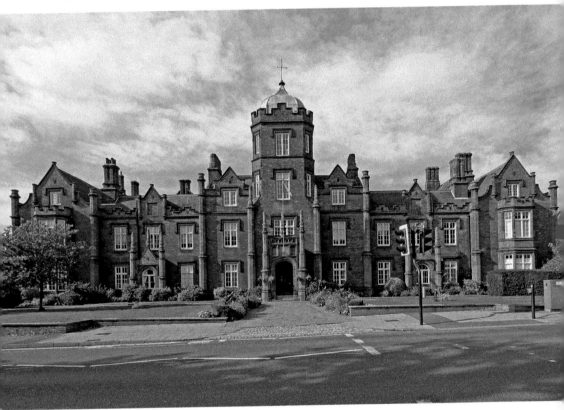

Ipswich School.

for over 200 years. A new schoolroom was then built on Lower Brook Street in 1843, but growing pupil numbers meant that a larger school was soon needed. The foundation stone for the current school was laid by Prince Albert in 1851 and pupils began studying here the following year. Christ's Hospital, another educational establishment in Ipswich, which had a long history of serving the poor of the town, was closed and had its endowments merged with those of the more prestigious grammar school on Henley Road in 1883. The school boasts an impressive list of former pupils, including Charles Sherrington, the pioneering neurophysiologist who was awarded the Nobel Prize for medicine or physiology in 1932; Rear Admiral Sir Philip Broke, a naval hero of the war of 1812 against the United States, who captained HMS *Shannon* in a celebrated engagement with the *Chesapeake*; and the Victorian novelist Sir H. Rider Haggard, best known for his hugely popular works *King Solomon's Mines* and *She*.

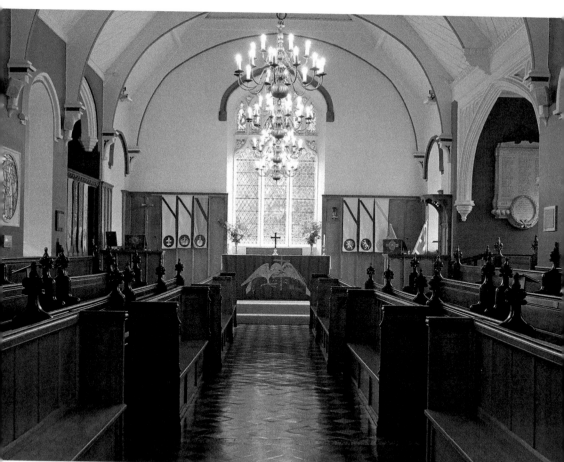

Inside the chapel at Ipswich School.

41. University of Suffolk Waterfront Building

Cardinal Wolsey, who was born in Ipswich, certainly had aspirations for the town to become a great seat of learning. He established Cardinal College at Oxford (now Christ Church College) in the 1520s and based the main feeder college for it by the Ipswich waterfront. Before the building work was finished, pupils had started their study at the institution. A letter from the master of the school attached to the college survives, expressing the thanks of the school and the people of Ipswich, including examples of some of the handwriting of the boys in attendance. Who knows what may have developed from these promising beginnings if the cardinal had not fallen from power upon failing to secure an annulment for Henry VIII's first marriage to Catherine of Aragon and the building of his college in Ipswich had not been abandoned as a

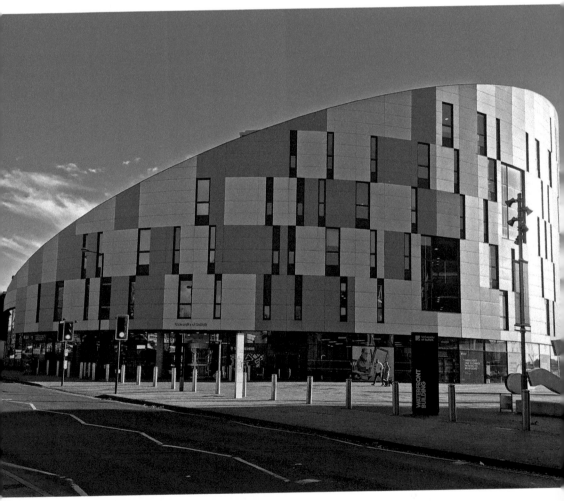

University of Suffolk Waterfront Building.

result. Almost 500 years later, in 2003, Suffolk County Council established a stakeholder group including the University of East Anglia and the University of Essex, among many others, with the aim of investigating the possibility of establishing a university for Suffolk. The University of Suffolk was originally founded as University Campus Suffolk in 2007 with its main campus in Ipswich. To begin with, the institution did not have degree-awarding powers and students received their degrees from either the University of East Anglia or the University of Essex, but in 2016 the institution became completely independent and was renamed the University of Suffolk and began awarding degrees in its own right. The iconic waterfront building with its curved roof, shown here, was designed by RMJM Architects and contains three lecture theatres as well as thirty-four teaching rooms. It was opened in 2008 at a cost of £35 million and has already become an important local landmark. A range of courses are now offered at the university, including Art and Design, Business Management, Computing, Film, Nursing and Midwifery, Social Sciences and Humanities.

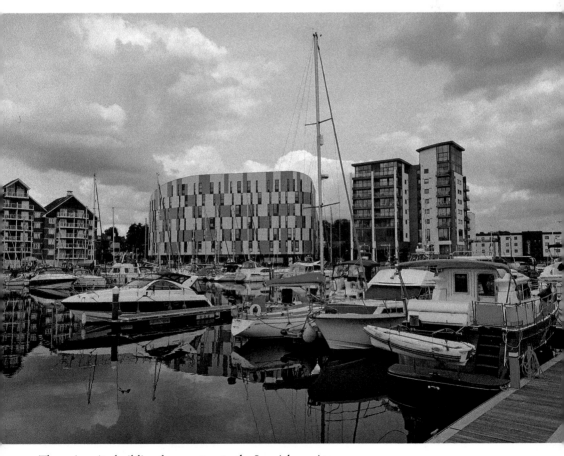

The university building faces out onto the Ipswich marina.

42. Ipswich Ragged School

In 1849, Richard Dykes Alexander, a Quaker banker and philanthropist, set up the Ipswich Ragged School for children from impoverished backgrounds not receiving an education elsewhere in the town. The school was originally established on St Clement's Church Lane, but later moved to new premises on Waterworks Street (pictured here). Children at the school were taught to read and write as well as to chop firewood and to work at carpentry. Joshua George Newman was the schoolmaster for nineteen years and ran the school with the help of his wife Deborah and some volunteers. At this time education was mainly left in the hands of religious and other charitable institutions as there was no compulsory education provided by the state. In 1870, the Education Act became the first piece of legislation to create education provision across the country. It established a system of school boards to build and manage schools in areas where they were needed, and schools such as the Ipswich Ragged School were phased out. This building then housed Waterworks Street Infants, which subsequently moved to Bond Street. The building on Waterworks Street was handed back to its former owners who continued to minister to the town's poor children in the evenings and on Sundays for many years.

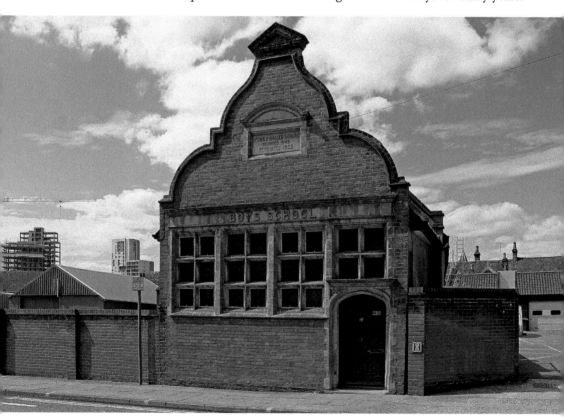

Ipswich Ragged School, Waterworks Street.

43. The Spread Eagle

Since the closure of the Old Bell, the Spread Eagle has become the oldest inn that remains open as a public house in Ipswich. This Grade II listed building probably dates back to the sixteenth century, but in the 1850s it was rebuilt to match the style of other nearby buildings. On closer inspection, at a former corner entrance to the pub are two spandrels featuring carved double-headed eagles that can still be made out. The Spread Eagle is the only survivor of four inns that once stood at the crossroads formed where Fore Street, Eagle Street, Upper Orwell Street and Orwell Place meet – the others were the Bull's Head, the Eclipse and the Shoulder of Mutton. It seems the Spread Eagle has had a dual role as a combined butcher's shop and inn over the centuries, as it was sold in 1747 'with a good Slaughter-House, good Conveniences for Brewing and all Brewing Utensils' and several of the landlords up to the early twentieth century were also butchers. The pub has recently found a new lease of life after being refurbished, and reopened in 2015 selling a wide selection of craft and imported beers.

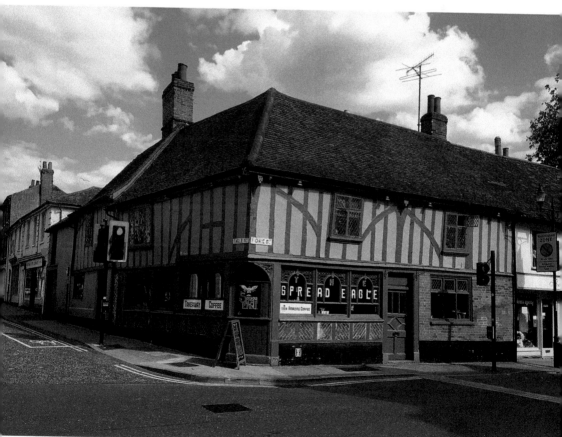

The Spread Eagle.

44. The Sun Inn

This Grade II listed timber-framed building on St Stephen's Lane was once an inn known as the Sun or the Rising Sun. It was first documented as an inn in 1458 and was a private home before that. The current building dates back to the sixteenth century, but, like most old buildings in the town, has seen alterations over the centuries. It's possible that the name originates from an image used by Edward III in his royal badge of a rising sun, used as a symbol of optimism. This symbol, after being popularised by royalty, was taken up by noble families across the country and many inns became so named. Edward III himself conferred a confirmatory charter upon Ipswich in 1338 and spent time in the town in 1340 before sailing with his ships amassed on the Orwell and Stour to a victory over the French fleet at the Battle of Sluys. The Old Sun is full of attractively restored rooms with

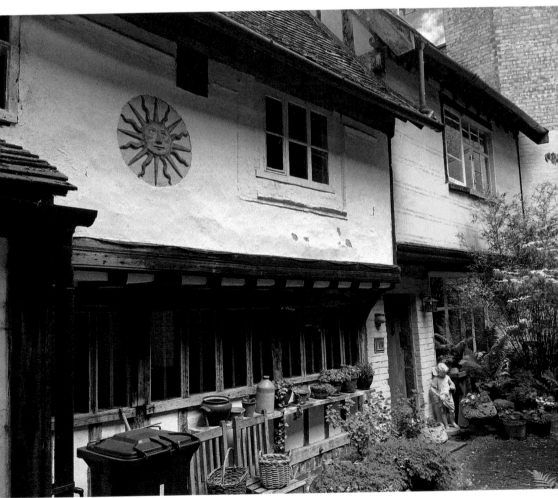

A pargeted sun is still visible on the outside of the building.

exposed timber-frames and even contains a dried-out well, which was probably used as a water source for townspeople before the building grew up around it. A small lane runs off St Stephen's Lane to form a courtyard around the Old Sun, which was made using setts (stones worked into a regular shape). Although this may seem like a small detail, it is actually one of very few places in Ipswich you can get a glimpse of the town's earlier street building materials. A fine pargetted sun sign still remains on a wall of the building in the courtyard. The inn came into the hands of the Cobbold family in 1796, who owned the building into the early twentieth century. As it is situated close to where the Old Cattle Market once traded, many of its regular customers would have been drovers and cattle dealers. After closing its doors as a pub, it was then an antiques and specialist book shop called Atfield and Daughter for many years. Today, the building is partly used as a private residence, still owned by the Atfield family, while the street-facing part is rented out as shop space.

One of the timber-framed rooms inside what was once the Sun Inn.

45. Old Packhorse Inn

This building on the corner of St Margaret's Street and Soane Street, once a coaching inn, is thought to date from at least the mid-sixteenth century. As its former name suggests, the Packhorse Inn was once popular with travelling pedlars and their horses as a place to stay. Pedlars were attracted to port towns like Ipswich because not only could they sell their wares to locals, but they could also purchase new, more exotic goods that made their way to the town from abroad. The inn is also thought to have been used by people travelling to the nearby Priory of the Holy Trinity before its estates were seized by Henry VIII in 1536 during the Reformation. Remarkably, one of the then inn's wooden corner posts still bears a carving of a shield featuring a cross with a sun and two moons, which is thought to be a symbol representing the Holy Trinity – this seems quite likely given its

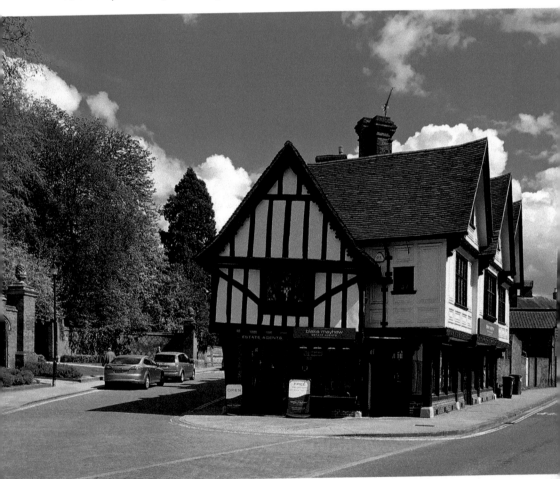

Above and opposite: Old Packhorse Inn.

proximity to the priory of the same name. Once Christchurch Mansion had been built on the site of the former priory, the Packhorse Inn would also have been used as accommodation for servants when the owners of the mansion received guests. It may seem odd that such a seemingly small inn provided rooms to so many travellers, but in fact it was once much larger. Alterations were made in 1936 in the process of road widening, which involved demolishing part of the structure and turning the side that once faced Crown Street at a right-angle so that it now faces St Margaret's Street. St Margaret's Street was at one time called Rotten Row, a name that had developed from its long-standing previous name 'Raten Row', which probably refers to a time at which it was rat infested! The exact date the Pack Horse Inn closed is uncertain, but as it doesn't appear to feature on maps in the late nineteenth century it seems to have already closed by then. It is now a Grade II listed building and in more recent years it has been made use of as a guitar shop and, currently, an estate agents.

46. Isaacs on the Quay

This complex of buildings along the waterfront has been a hive of commercial and industrial activity for many centuries, with the earliest parts of it dating back to the early 1400s. The original owner is unknown, but it appears that early on in the building's history it belonged to a wool merchant at a time when Ipswich was a very important exporter of woollen cloth. The collection of buildings here includes the Saleroom, which is thought to be the part that acted as a warehouse that customers could enter to inspect the merchant's cloth for sale. Back then, a channel of water flowed through the courtyard from the river so that cloth could be loaded directly on and off barges. The name associated with this complex of buildings comes from Isaac Lord, who bought the property from the Cobbold family in 1900. The Lord family developed the site to run a corn and coal business here until the 1980s, producing the malt from Suffolk barley that was used by the nearby Cliff Brewery. The kiln where malt was once

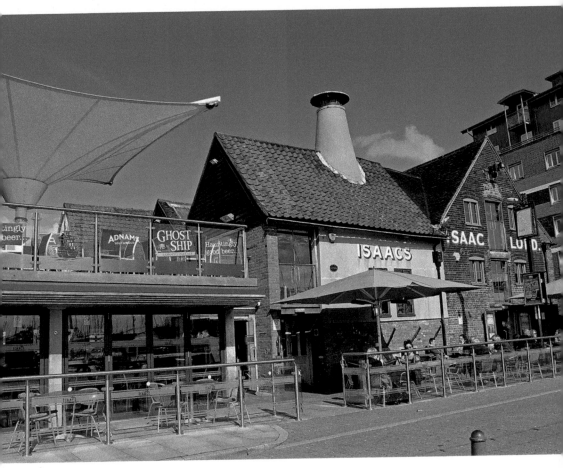

Isaacs on the Quay.

dried was converted into a public house in 1984. Since then, the complex has been restored and developed so that original features are celebrated and many pieces of industrial equipment from the building's past are on display. There are also some interesting examples of a building technique at Isaacs known as 'nogging', which is the term for where bricks are used to infill the space between the timber frame of a building. On some of the walls at Isaacs the bricks used in this nogging are set in an unusual diagonal pattern. The group of buildings that make up what has come to be known as Isaacs on the Quay have found new uses as several bars, a coffee shop and a pizzeria. Since the transformation of Ipswich waterfront from a hub of industry to a place of leisure and recreation it has become one of Ipswich's most popular locations for drinking and eating, as well as being a popular wedding venue.

Courtyard within Isaacs on the Quay.

47. Old Neptune Inn

For a large part of the town's history, Ipswich's docklands were home to many of the town's merchants who lived alongside their businesses and ships, with living quarters facing the street while the more commercial parts of properties would run down to the waterside. The Old Neptune Inn began its life in the fifteenth century as one such merchant house. The occupants of this property must have been reasonably successful as the building was expanded, with two additional floors being added in 1639. The building was converted to an inn sometime in the eighteenth century and appears to have continued to be used as a pub or inn of one sort or another from then until 1937. A particular distinction of 'Ye Olde Neptune Inne', as it would come to be known, was that Ipswich dock labourers received their pay there in the bar parlour during the eighteenth and nineteenth centuries – something that was probably an advantage to the business of the inn, it is to be imagined! It also had a reputation for being involved in smuggling.

The Old Neptune Inn.

This may be romantic speculation, but is certainly possible, as the River Orwell has seen its fair share of smuggling over the centuries, particularly in the 1700s. The Old Neptune once had a spectacularly crooked tall chimney, which is recorded in photographs and paintings into the early twentieth century, but has since disappeared from the rooftop. After the closure of the inn, the building was used as a store during the Second World War, before being purchased in 1947 by George Bodley Scott, a director of the local printers W. S. Cowell. The building had been allowed to fall into a state of disrepair, but Scott set about restoring the building, carrying out much of the work himself. It then became a private house in the 1960s. Today the Old Neptune is a Grade II* listed building and is available to hire out for social or corporate events. It is deceptively large within, including, among other things, a dining hall, beautiful courtyard and thirteen bedrooms.

Courtyard of the Old Neptune Inn.

48. Great White Horse Hotel

The Great White Horse has stood in its current location since at least 1518. In medieval times there was a building on the same spot referred to as 'the Tavern', which would have been one of the inns used by pilgrims visiting the nearby shrine of Our Lady of Grace (then one of the most high-profile shrines in the country). Between 1815 and 1818, due to the widening of Tavern Street, the Great White Horse lost its original timber-framed front, which was replaced with the current frontage of Suffolk white bricks. Charles Dickens stayed at the Great White Horse on several occasions and in *The Pickwick Papers* (1836) he described the place as:

Famous in the neighbourhood, in the same degree as a prize ox, or a county paper-chronicled turnip, or unwieldy pig – for its enormous size. Never were such labyrinths of uncarpeted passages, such clusters of mouldy, ill-lighted

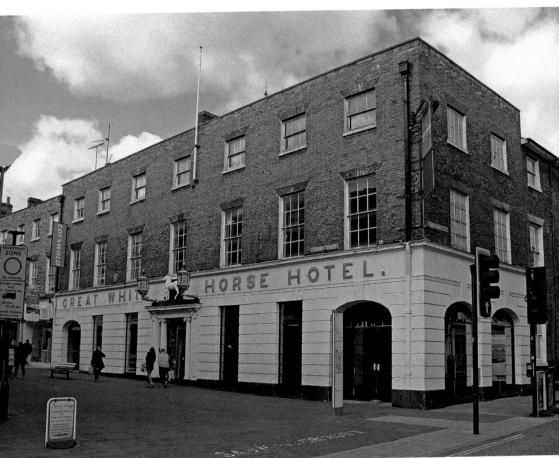

Above and opposite: The Great White Horse Hotel.

rooms, such huge numbers of small dens for eating or sleeping in, but beneath any one roof as are collected together between the four walls of the Great White Horse at Ipswich.

Dickens extracts humour from this point by having Mr Pickwick become lost on his way back to his room, ending up in another guest's four-poster bed by mistake, and then being ejected from the room. Thanks to Dickens, the Great White Horse became briefly internationally famous when it was chosen to be the building that represented Britain in the 1893 World's Fair in Chicago. A full-sized (but inaccurate) replica of the building was constructed so that visitors where able to enter to experience what it was like in an archetypal British inn. Other notable patrons of the Great White Horse have included George II and Admiral Nelson. After attempts to modernise during the twentieth century (updating its coaching facilities to cater for motor cars), the hotel finally closed its doors in 2008. Part of the building has since reopened as an outdoors shop and a branch of Starbucks was also located on the ground floor until it closed in 2018. The building continues to retain its well-known façade and lettering as well as many of its original interior features.

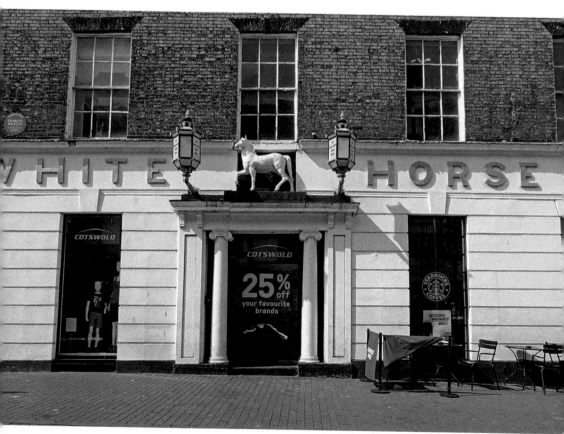

49. Crown and Anchor Hotel

Along with the Great White Horse, this building was once one of Ipswich's grandest hotels. Other inns once stood on this site before the Crown and Anchor – the earliest known was the Griffin, which dated back to at least the first half of the sixteenth century. As well as being an inn it also hosted theatrical performances in its large yard. The site became known as the Crown and Anchor in the early nineteenth century, but the old building was demolished in 1838 and was rebuilt in the 1840s. The ornate front was designed by Fred Russell and then rebuilt and extended by Thomas W. Cotman in 1897. The name of the former hotel is still present in stone lettering on the frontage over the entrance. Plans were made to demolish the hotel in the 1960s in order to build new retail spaces. Fortunately it was saved thanks to those against the demolition citing historical features within the building. The Crown and Anchor Hotel was eventually converted into shop space in the early 1990s and some of the original features including the entrance foyer and its tiled floor remain in place within what is now home to a branch of WHSmith.

The Crown and Anchor Hotel – now a branch of WHSmith.

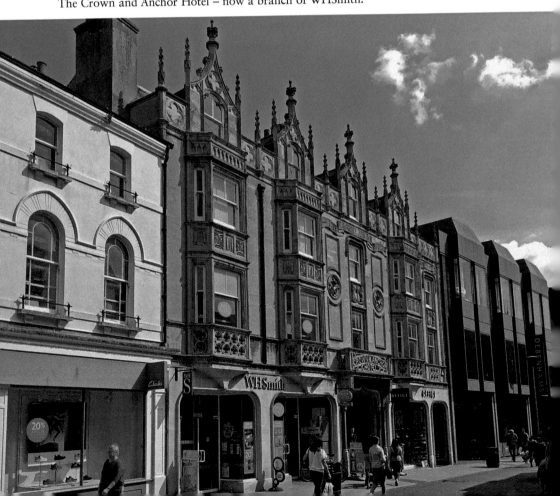

50. Royal Oak

This fine plastered building with exposed timber framing on the corner of Oak Lane and Northgate Street has stood here for centuries, with the oldest parts probably dating back to the late fifteenth or early sixteenth centuries. It was originally a private residence, but appears to have become the Royal Oak when the licence was transferred from a public house of the same name in Tavern Street. There is some uncertainty about when exactly the Royal Oak on Northgate Street opened due to some ambiguity in historical sources relating to it, but it seems it was already open by 1714. The building has many fine carved timbers, including one of the corner posts, which features a depiction of a blacksmith striking an anvil. These types of ornately carved timbers were once common on houses across Ipswich, but during the twentieth century many were pulled down. Fortunately, many timbers from these demolished buildings were saved and are now in the care of Ipswich Museums Service. The Royal Oak was closed by Cobbold & Co. in 1882. The building was then bought by T. W. Cotman, a local architect, who did considerable work to restore it with features from other, demolished, Ipswich buildings, while also retaining many original features. Oak House, as it is now known, is used today as offices by Jackamans Solicitors.

Oak House – once the Royal Oak.

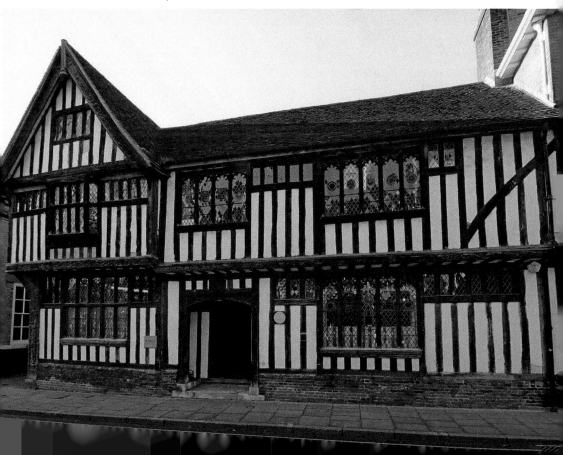

Bibliography

Bishop, Peter, *The History of Ipswich 1500 Years of Triumph & Disaster* (Unicorn Press, 1995)

Blatchly, John, *A Famous Seed-Plot of Learning, A History of Ipswich School* (Ipswich School, 2003)

Bruce, Paul and Richard Scott, *High Street Heyday Memories of the Ipswich School of Art* (Colchester and Ipswich Museums Service, 2011)

Gardiner, Susan, *Ipswich Pubs* (Amberley Publishing, 2016)

Hanson, Eric H., *An Historical Essay of the Ipswch Institute 1925–1987, with a reprint of 'The Ipswich Institute 1824–1924' by Herbert Walker* (The Committee of the Ipswich Institute, 1989)

Kindred, David, *Ipswich Lost Inns, Taverns and Public Houses* (Old Pond Publishing, 2012)

Malster, Robert, *A History of Ipswich* (Phillmore & Co. Ltd, 2000)

Malster, Robert, *An A to Z of Local History* (Wharncliffe Books, 2005)

Markham, R. A. D., *A Rhino in High Street* (Ipswich Borough Council, 1990)

Redstone, Lilian J., *Ipswich Through the Ages* (East Anglian Magazine Ltd, 1948)

Smith, Frederick G., *The Bethesda Story Re-told* (Avon: The Bath Press, 1988)

Thompson, Leonard P., *Old Inns of Suffolk* (The Ancient House Press Ipswich, 1946)

Tricker, Roy, *Ipswich Churches Ancient and Modern* (Brechinset Publications, 1982)

Twinch, Carol, *Ipswich Street by Street* (The Breedon Books Publishing Co. Ltd, 2006)

Websites

www.britishlistedbuildings.co.uk
www.ipswichhistoricchurchestrust.org.uk
www.ipswich-lettering.co.uk
www.suffolkchurches.co.uk